"As someone who has struggled with the fear of rejection my whole life, I found *Confidence Is an Inside Job* deeply resonating. As both companion and guide, Ashley Henriott leads you through the hard work of building confidence in Christ. She offers reflection questions at the end of each chapter to uncover what is really happening in our hearts and minds so we can break free from what is holding us back. Ashley's vulnerability and courage helps us feel less alone on the journey to walk in the confidence we are called to. This book is a great resource for anyone who wants to learn how to fully rely on Christ."

—ASHLEY MORGAN JACKSON, bestselling author,
speaker, and writer for Proverbs 31 Ministries

"Ashley Henriott's new book is a must-read for any woman who has ever doubted her worth or felt pressured to be someone she's not. Drawing from her own transformative journey, Ashley offers deep, Christ-centered wisdom that cuts through the lies society tells us about our value. With her signature humor and authenticity, Ashley shares inspirational stories and practical strategies to combat the confidence killers—fear, inaction, and comparison. Her relatable and heartfelt insights will guide you to a profound confidence rooted in your relationship with Jesus. *Confidence Is an Inside Job* is a powerful resource for anyone seeking to embrace their unique worth and live a life of true confidence."

—DAYNE KAMELA, founder of Litwithprayer

"In a toxic culture where image crafting covers up our anxieties and depression, Ashley powerfully guides us to the heart of our stories, revealing how hope comes alive when we show up with our self-doubts to God who heals. *Confidence Is an Inside Job* helps strengthen our broken places with true inner confidence that comes from God's love for us. In this deeply moving read, Ashley artfully weaves biblical truth with her amazing story of rescue and redemption that will leave you more whole simply by reading it."

—BONNIE GRAY, founder of Soul Care School
and bestselling author of *Breathe*

"In *Confidence Is an Inside Job,* Ashley shares her heartfelt story and vulnerable experiences to remind women that they too are worthy and valuable. This book is an incredible asset for any reader looking to walk more confidently in the direction of Christ's leading, regardless of how uncertain, unfamiliar, or unsupported that path may be."

—COURTNEY J. BURG, author of *Loyal to a Fault*

"Every woman I know struggles with confidence to some degree. Every Christian woman I know struggles with anchoring herself to her identity in Christ. In *Confidence Is an Inside Job,* Ashley takes us on a beautifully personal journey that will help you conquer self-doubt and embrace God's view of YOU. You don't want to miss it!"

—REBECCA GEORGE, author of *Do the Thing*
and host of the *Radical Radiance* podcast

Confidence

Is an Inside Job

Confidence
Is an Inside Job

CONQUER SELF-DOUBT AND
EMBRACE GOD'S VIEW OF YOU

Ashley Henriott

WATERBROOK

All Scripture quotations, unless otherwise noted, are taken from the Holy Bible, New Living Translation, copyright © 1996, 2004, 2015 by Tyndale House Foundation. Used by permission of Tyndale House Publishers, Carol Stream, Illinois 60188. All rights reserved. Scripture quotations marked (ESV) are taken from the ESV® Bible (The Holy Bible, English Standard Version®), copyright © 2001 by Crossway, a publishing ministry of Good News Publishers. Used by permission. All rights reserved. Scripture quotations marked (MSG) are taken from *The Message,* copyright © 1993, 2002, 2018 by Eugene H. Peterson. Used by permission of NavPress. All rights reserved. Represented by Tyndale House Publishers. Scripture quotations marked (NIV) are taken from the Holy Bible, New International Version®, NIV®. Copyright © 1973, 1978, 1984, 2011 by Biblica Inc.™ Used by permission of Zondervan. All rights reserved worldwide. www.zondervan.com. The "NIV" and "New International Version" are trademarks registered in the United States Patent and Trademark Office by Biblica Inc.™

Italics in Scripture quotations reflect the author's added emphasis.

Published in the United States by WaterBrook, an imprint of Random House, a division of Penguin Random House LLC.

WATERBROOK and colophon are registered trademarks of Penguin Random House LLC.

LIBRARY OF CONGRESS CATALOGING-IN-PUBLICATION DATA
Names: Henriott, Ashley, author.
Title: Confidence is an inside job: conquer self-doubt and embrace
God's View of You / Ashley Henriott.
Description: First edition. | Colorado Springs: WaterBrook, 2024. |
Includes bibliographical references.
Identifiers: LCCN 2024008420 | ISBN 9780593601013 (hardcover;
acid-free paper) | ISBN 9780593601020 (ebook)
Subjects: LCSH: Confidence—Religious aspects—Christianity. | Christian women.
Classification: LCC BV4647.C63 H467 2024 | DDC 248.8/43—dc23/
eng/20240513
LC record available at https://lccn.loc.gov/2024008420

Printed in the United States of America on acid-free paper

waterbrookmultnomah.com

2 4 6 8 9 7 5 3 1

First Edition

Book design by Debbie Glasserman

Most WaterBrook books are available at special quantity discounts for bulk purchase for premiums, fundraising, and corporate and educational needs by organizations, churches, and businesses. Special books or book excerpts also can be created to fit specific needs. For details, contact specialmarketscms@penguinrandomhouse.com.

To you, the woman who's flipping the pages of this book,
who's searching for what it truly means to be confident in Christ:

loved, bold, and accepted.

Maybe you've been told you're not smart enough.
Or pretty enough.
Or good enough.
Or wise enough.

Maybe someone hasn't treated you the way they should.
Maybe that someone is you.

I want you to know something, friend:
You don't have to stay there.
You don't have to wait for someone to tell you that you belong.
You don't have to be enough for anyone anymore,
because you are already enough for Jesus.

Remember: You were made for *more*.
More love, more joy, more trust in yourself.
And above all, you were made for more confidence in yourself
 and in your Savior.

That's what I hope you learn as you make your way through
 this book.

I'm so proud of you for choosing *you* today, sis.
I can't wait to go on this journey with you.

Foreword

CONFIDENCE IS A STRANGE THING, ISN'T IT? IT'S LIKE AIR. WE CAN'T see it, but we know we need it, and we can't survive without it. The culture of this world tries to convince us that our sense of self is wrapped up in literally everything but God. Yet none of those things seems to satisfy our soul's desperate longing for worth.

When I first stumbled upon Ashley Henriott online, her humor caught my attention, but her heart kept me coming back for more: more wisdom, more biblical insight, more honesty, and of course, more lighthearted laughs. You may not realize it, but those who bring the greatest joy into the world often carry the deepest wounds—and Ashley's scars run deep. As a fellow survivor of child abuse who has been diagnosed with complex post-traumatic stress disorder, I heard echoes of my own story within Ashley's, but more importantly, I saw with profound clarity God's sovereignty in all our stories.

In this book, Ashley tenderly walks her readers down memory lane, revisiting the heartache of her childhood and the victories and hard-won wisdom that came along the way. Ashley isn't a stranger to tragedy or trauma, and she doesn't attempt to sugarcoat the bitterness of life. Her words are wrapped in empathy, her sincerity is palpable, and she has the remarkable ability to both challenge us and comfort us with each turn of the page. I can't think of anyone more qualified to speak into this generation of women on the topic of confidence in Christ than my girl Ashley.

Drawing on powerful biblical teachings, she emphasizes that your identity and self-worth must be found first and foremost in the belief that you are God's beloved child. Then you can conquer self-doubt and embrace your God-given confidence—confidence that the world cannot give you and therefore cannot steal from you.

As you read, I pray that your heart would be softened and receptive. I pray that your eyes would be opened to the truth of God's heart toward you, and that you would hold tightly to the wisdom poured out onto these pages and allow the power of God's Word to fill you with confidence. May you know the nearness of God within you and may the power of the Holy Spirit transform you.

If you're ready to overcome the barriers that the enemy of your soul has placed before you, keep reading. It's time to take agency of your life and become the person you were created to be, confidently.

CASSANDRA SPEER, author, Bible teacher, and
vice president of Her True Worth

Contents

FOREWORD BY CASSANDRA SPEER vii

INTRODUCTION xi

Part I Confidence 101 1

CHAPTER 1: Why Do We Care So Much? 3

CHAPTER 2: What Is Confidence? 19

CHAPTER 3: Coming to Your Own Rescue 38

CHAPTER 4: How to Show Up for Yourself 56

Part II Confidence Killers 75

CHAPTER 5: The Lowdown 77

CHAPTER 6: Breaking Free from Fear 91

CHAPTER 7: Overcoming Inaction and Avoidance 110

CHAPTER 8: Letting Go of Comparison 134

Part III Healing and Growing Your Confidence 157

CHAPTER 9: Resilience to Redeem Your Story 159

CHAPTER 10: Confidence for Your Next Chapter 174

CHAPTER 11: Confident in Christ 192

ACKNOWLEDGMENTS 199

NOTES 201

Introduction

I keep my eyes always on the Lord.
With him at my right hand, I will not be shaken.

PSALM 16:8 (NIV)

CLOSE YOUR EYES, AND PICTURE YOURSELF ON A RED CARPET.

Maybe it's the Oscars or the Grammys. Maybe it's a movie premiere, and the actor you crushed on all through your childhood is standing five feet away from you. Normally, you'd be a melting puddle of goo, ready to take your bedhead and three-day-old sweatpants and go hide in a corner. Except . . . you remember you're on the red carpet. And the last time you looked in a mirror before you hopped in the limo, you thought to yourself, *Wow, I look good.* Your hair is full and luscious, like you're starring in a shampoo commercial. And your dress—where did you get this *dress*? It's a step up from your usual Amazon Prime find. It hugs your curves and drapes your body in the most elegant way, and guess what? It has *pockets.* Your ears and neck and wrists are dripping with diamonds.

You've come a long way, baby, from sweatpants—heck, even

from a past you'd like to put behind you. You're the total package, and this is your time to shine.

As you stand just outside your limo, getting ready to walk the carpet toward the entrance of the theater, you realize a crowd has formed in front of you and blocked your way. And this isn't just any crowd; you look at each face, and they all look familiar. You see your mom first. Then your dad. Your grandmother. Your loud aunt. Your friends from church. Your pastor. Your favorite influencer has even made an appearance. But you can't see past them to go where you're supposed to. In an instant, panic sets in. You're still smiling for the cameras, calm and poised, but on the inside, your brain is moving a thousand miles an hour as you ask yourself, *What's everybody doing here? What do they need? What am I supposed to be doing right now?*

Before you can venture another thought, the crowd made up of your favorite people begins to yell things at you: "Why are you walking this way? You need to go over *there.*" You always listen to your people, so you stop to think about what they're saying and how to please them. But you realize: You're not sure where *there* even is.

What is going on?

Clearly, they must know something you don't. The entrance where you *thought* you were supposed to go is just beyond them, so you'd have to make your way past them to get there. But you also trust these people. Surely they know where you're *really* supposed to go. So you try to keep moving in the direction they're pointing you—over there. Wherever that is.

As you try to figure out your next step, you pause to take a ragged breath. Your heart is pounding in your chest. You're so anxious, trying to think about how to do All the Things and please All the People, and you're not sure how.

So, even as your gut is screaming for you to stop, you step off the red carpet.

All of a sudden, your people surround you. You're rushed into a side room, where they have another gown for you to change into. It's a whole new look—a dress that your mom might pick out. It's not completely *you,* but these are your people. They know what looks best, and they want the best for you. So you decide to trust them and change into the new dress. You look in the mirror and don't feel as foxy as you did before, but that's okay. This has to be the right thing.

After one last look in the mirror, you turn as someone thrusts a new itinerary for the evening into your hands, telling you what to say, what not to say. What to do, what not to do. Where to go, where not to go.

It's all starting to feel like too much.

You step out of the room, this time flanked by your entourage. They're still yelling directions at you, but now they're all yelling different things.

"Lose the necklace!"

"No, keep it!"

"Let's get you over to the theater!"

"No, you're needed back in the studio!"

"C'mon, this way!"

If you were confused before, you're *seriously* paralyzed now.

Desperate, you look back toward the red carpet, and in the distance, you see Someone else who looks familiar—he's at the entrance where you were headed in the first place. He's calm and sure, standing and waiting. In the chaos, you're trying to make out what he's saying, and you *think* you hear his soft, warm tone: *Just follow my voice—and trust me.*

He's the calmest one around and also the most gentle. He's

never steered you wrong before. As you hear his reassuring words, you make a decision: You're going to go with him. And you'll do whatever it takes to make your way over to him.

And just like that, the fog begins to clear, the fluttering in your stomach vanishes, and you feel an overwhelming sense of empowerment. You realize that although you love the people who are trying to shepherd you, you aren't supposed to go with them. You *have* to get to that entrance, over to him, no matter what. It's not an easy path. All those people are still yelling: "No, not that way—this way! Right over here!"

Their hands begin to reach for you, but you push them away. Someone's fingers close over your gown, and your forward momentum tears it. But you keep your eyes on the entrance, knowing it's the only place for you to go. The only way out of this chaos.

As you get closer, the crowd of your people is still there, but their voices aren't loud anymore; they're fading into the background. Now the only thing you can see is him. Standing there. Waiting for you. Saying to you over and over, *My voice is the only one that matters. Come to me. Follow my voice.*

You feel at peace as you arrive at the entrance, even if you've looked . . . better. Your once-perfect hair resembles your regular tousled mop. Your dress is in tatters. You can feel the blisters forming at your heels after you pushed so hard in your pumps to make it here. But you don't care. He doesn't care either. And in spite of everything, in spite of your weary body, your spirit feels resilient, confident that, with him, you can make it through anything.

As you step onto the red carpet just as you are, tatters and all, suddenly you're transformed. Now you're even more stunning.

You're beautifully confident as you walk right where you're supposed to be: arm in arm with Jesus.

. . .

FRIEND, THIS ISN'T A FAIRY TALE. THIS KIND OF CONFIDENCE IS *REAL*. I know, because this journey down the "red carpet" has been my own. And trust me when I say that confidence—this life-changing belief in yourself and what you're capable of, especially when you're walking beside a Savior who loves you—can be yours too.

Now, will you still want other people to like you? Will you still want to be in relationship with other people, listen to their counsel, and enjoy bringing happiness into their days? Absolutely—there's nothing wrong with that. But, sis, you can't base your worth on the expectations of others. You can't derive your confidence from what people around you think of you. That's a recipe for disaster, because you will never ever live up to their expectations.

You might be thinking, *Okay, Ashley, how am I supposed to be confident? Where does that come from?* Well, I'm going to show you.

First we're going to walk through what, exactly, confidence is. We'll reach into our backpacks (Did you know you're carrying a backpack right now? Yep, you are! We'll talk about that more in a bit), and one by one, we'll look at the tools packed in our bags, each given to us by God to help build our confidence from the inside. We're going to talk about some of the biggest confidence killers and how to overcome them. Then we'll end

on how to put all the steps together so we can confidently walk our God-given path with our mission in mind.

At the end of each chapter, I've laid out three sections to guide you as you begin to work on your confidence: "The Foundation," "The Tools," and "The Build." "The Foundation" section is for those TL;DR moments, because—let's be real—we all have those days when an entire chapter is too long to read. There I give you takeaways from each chapter (though I do recommend you read through the chapter when you have the time). "The Tools" has quick tips and practical pieces you can use in your life *today.* Finally, "The Build" has questions for you to do the internal work of building confidence. Sit with them; journal the answers in a notebook or in your Notes app; talk about these questions with a friend—however you choose to tackle them, don't skip these questions. Wrestling with big questions isn't easy, but it's so important for you to sit with the hard stuff for a minute as you build your confidence from the inside.

Sis, your best self is inside you—right now, this very minute! And she doesn't have to care what others think. Together we are going to find her, strengthen her spirit, and help her walk the path she was called to live.

Are you ready?

I can't wait to take you by the hand and walk with you on one side, with Jesus on the other, as you realize something about yourself: that confidence is an inside job.

PART I

Confidence 101

Why Do We Care So Much?

> This is what the LORD says:
> "Stand at the crossroads and look;
> ask for the ancient paths,
> *ask where the good way is, and walk in it,*
> *and you will find rest for your souls."*
>
> JEREMIAH 6:16 (NIV)

IT WAS THE FIRST DAY OF KINDERGARTEN. I WAS IN MY FAVORITE PINK dress and the cutest white high-top tennis shoes, which I had to beg my mom for because they were white, and she absolutely knew they wouldn't come home that way. (She was right.) My hair was pulled back into pigtails, my favorite style, because my grandma always told me how cute I looked when my hair was that way.

Precocious was the word most adults used to describe me, which just meant "loud and in charge." I was a force to be reckoned with wherever I went. "Too much" is what my dad would say. "Ashley, remember when you get into class today, just don't be too much. Tone it down. Don't draw too much attention to yourself if you want the other kids to like you." That was Dad, though, always telling me to take it down a notch. It's safe to say my big personality was *not* his favorite thing about me.

But the second I entered the classroom, Dad's advice went right out the window. I walked in on top of the world. Confi-

dence was never a problem for me back then, and on this particular day, I felt especially pretty. I quickly sized up the other kids, making eye contact right away with girls and boys who seemed like best-friend material.

"Hi! I'm Ashley," I'd say, a little too loudly and a little too close to their faces.

Later that morning, my teacher announced we were going to make a fun project for our first day of school by drawing a life-size picture of ourselves. She gave each of us a large piece of white butcher paper, and then she paired us with a partner who would draw our outline while we were lying on the floor.

The girl I was paired with rolled her eyes and whispered to her friend next to her. They both looked in my direction and giggled. I wondered what was so funny and hoped she'd tell me while we were working together.

I traced her outline first, taking extra-special care to get it just right. Then it was her turn. She traced me, giggling again as she tried to outline around my pigtails and the flare of my dress. She didn't talk much, but her silence didn't bother me. I could easily carry any conversation by myself.

Once we were finished with the tracings and added details, everyone laughed as they looked at their classmates' drawings. My boys have each made one of these outlines on their first day of kindergarten, and I imagine you or your kiddos might have done one as well, so you *know* what they look like. The phrase "Picasso goes to kindergarten" comes to mind.

I looked at my finished drawing and felt such pride in my work. Did I look silly? Absolutely. We all did. But my tracing partner and her friend seemed to be especially interested in pointing out everything wrong with *my* picture, which was obviously a stand-in for my actual appearance. My pigtails were

too babyish. My dress was too fancy. And who wears *tennis shoes* with a *dress*? (Can you tell this was the '90s and not the 2020s?)

It was the first time I really remember caring what someone else thought about me. And I remember how it made me feel: panicky.

Heat flooded my cheeks. My breath came in spurts; my heart was beating out of my chest. My thoughts started spinning a million miles an hour, jumbling together as I tried to figure out how in the world I was going to make friends with these girls—and what I might have to change about myself to do it.

This was in *kindergarten*, y'all. My heart breaks for little five-year-old me.

When I (thankfully) got off the bus that afternoon, I ran straight into my mom's arms and cried. "They don't like me, and I don't know why!" I moaned into her shoulder.

I don't remember what she said to comfort me. I'm sure it was something moms say to comfort little hearts, but I've never forgotten that day—or the pain of those girls' words.

So I vowed that from that day forward I would do whatever it took for those girls not to just like me but to *love* me.

PEOPLE-PLEASING 101

The need to feel liked, accepted, included, starts when we're young, doesn't it?

The need to feel liked, accepted, included, starts when we're young.

In reality, searching for acceptance starts way before we head off to kindergarten, long before the influence of friends or social media. From our earliest ages, we begin to adjust our behaviors based on what we sense as pleasure and displeasure from others.

How do I know? I've seen it in my children from the time they were little.

Ever played the "throw it on the floor" game with a baby in a high chair? They throw something on the floor. You laugh, pick up what they tossed, set it back on the high chair, and what do they do? They throw it on the floor again, right? The more you laugh, the more they sense your approval, and they keep throwing the object on the floor. Of course, it's not so funny when things escalate and they throw their bowl of oatmeal on the floor, but the whole interaction is based on the good feelings they get from pleasing you.

We are encouraged by the praise of others. That encouragement feeds us in a way that triggers all kinds of happy brain chemicals, and we start to chase praise when we're very, very young. It's not something we ever really outgrow. And there's a reason for that. We were never intended to outgrow our desire to be accepted.

Because God made us that way.

From the moment God created Adam, he was pleased. Then when God saw that Adam needed companionship, he created Eve. And he was pleased with her too. In fact, the Bible tells us that "God saw all that he had made, and it was very good" (Genesis 1:31, NIV).

The Bible doesn't talk a lot about what Adam and Eve were thinking in those early days in the garden. But since we still talk about the Garden of Eden today as a place of paradise, I'd like to think that, in this perfect place, Adam and Eve were happy and

content. They were in relationship with God and with each other, and there were no outside forces compelling them to pull away from one another.

But that didn't last forever, did it?

You know the story. The serpent convinced Eve to eat fruit from *the one tree* in the garden God told her not to eat from. Satan convinced her to eat that fruit by making her feel like something was missing in her life, something God didn't want her to have. Once she'd eaten the fruit, she convinced Adam to eat it too. Perhaps without thinking of the consequences, Adam and Eve decided to separate themselves from God. And God decided to show this separation physically by banishing Adam and Eve from the perfect paradise he'd made.

Oh man, the lessons we can take away from one little (but oh-so-huge) story.

First, when I said that people-pleasing has been around for a while, *I wasn't kidding.* This is the story of the very beginning of human history, and it's about people-pleasing. So don't feel bad if you struggle with trying to make everyone around you feel happy—because humans have been struggling with it literally since the dawn of time.

Adam cared a lot about pleasing Eve. And why wouldn't he! She was his wife, his BFF. They were thick as thieves in the garden. But here's the problem: When he decided to take that fruit from Eve, he cared more about pleasing his wife than he cared about pleasing God. And God doesn't make his rules in a "because I said so" sort of way. He doesn't need us to obey him for an ego boost. I mean, he's *God*—he can do what he wants. He makes these rules because he knows what's best for us. He created guidelines because he knew we'd need them, like instructions in a recipe.

Adam and Eve decided they didn't really *need* the instructions and were going to start making decisions without God. And you know what? It isn't hard to see that acting against our own best interests (like, you know, listening to what God has for us) to please someone else can quickly backfire. And backfire it did.

And that's really the problem with people-pleasing. Making others happy feels good. Meeting the needs of others feels good. When others approve of us, we feel good. But honestly, working so hard to please other people is a bit shortsighted, because what feels good in the moment isn't always good for us in the long run. When we believe that pleasing other people is the only way to contentment and the only way we're worthy of love and belonging, that's a big fat lie from Satan—a lie that's easy to believe. Clearly.

But hold on, Ashley, you may be thinking. *Am I just supposed to make people mad all the time? How am I going to have any friends if I'm just ticking people off? How are my loved ones going to continue talking to me if I don't do anything that makes them happy?*

Okay, valid question. I get why you're asking it: Who wants to be Debbie Downer, who keeps to herself and doesn't laugh or do anything fun with anybody? No one—that's who. And that's not what I'm telling you to do here. Sharing joy with other people is one of the best parts of connection; there's a reason Proverbs says, "A joyful heart is good medicine" (17:22, ESV). So rest assured, I'm not telling you that doing something kind for someone else, whether it's baking spider cookies for the neighborhood Halloween party or watching your friend's kids one night when she asks, is bad and you're doing something wrong. Absolutely not. But what I *am* saying is that there's a difference between giving of yourself in a healthy way that brings joy, connection, and flourishing to a relationship and the not-so-healthy

giving of yourself that has you believing that your contribution to someone else is the *only* thing that brings you worthiness as a human being. And when you believe that your worth comes from your actions? Well, that's a recipe for resentment, anxiety, and burnout at best. At worst, it puts you on a path that leads away from God's mercy and love, which contribute so much to the person he wants you to be.

So how do you know if you're making a decision to be kind to someone else and contribute to a group or if you're spiraling into some self-destructive people-pleasing? Here are a few red flags to look for:

- Have you ever made a decision you *knew* was the wrong one, but you didn't want to hurt someone else's feelings by going in another direction?
- Have you ever stopped yourself from communicating any hurt or anger you feel, because you just wanted to keep the peace?
- Do you feel like you *need* the praise of your friends to feel good about yourself?
- Have you ever apologized for something you didn't do, because it was easier than continuing the argument?
- Have you ever felt loved or unloved based on the number of likes or comments you received on a social media post? (*Ouch.* That one hurt a little.)

These are all signs that you might be making decisions from a people-pleasing place.

And you know something? Even when we're aware that making choices to please others instead of God isn't great for us, because it takes away our flourishing, we still wonder time and again, *What will other people think of me if I do (or don't do) this?*

Did you just feel a shot of adrenaline in your veins? I did too. Because even though I know—I *know*—I'm not supposed to care what other people think about me . . . I do. I very much do. It's something I struggle with a lot, and I bet you might too.

It's okay, sis. You're not alone here. But you may be wondering why we struggle so much with that.

Well, it's because we all have a very deep need to be needed and known.

NEEDED AND KNOWN

Abraham Maslow, renowned psychologist, developed what has come to be known as Maslow's hierarchy of needs. This hierarchy tries to explain how our needs drive our choices and behavior.

Maslow's hierarchy of needs is often shown as a pyramid graphic with the most basic needs (like food, safety, and love) toward the bottom of the pyramid and the highest need, which he called "self-actualization," at the top.[1]

I don't think Maslow gets nearly enough credit for his theory. I mean, I *know* people are aware of the hierarchy of needs, but we should've given this man all the prizes. Because so many of our choices can be explained by this one simple pyramid. And lucky for you, we're going to nerd out and break it down because this is some fascinating stuff.

At the bottom of the pyramid are the basics of what we humans need: food, water, shelter, sleep—things like that. At the very least, we need these things to function. If we don't have these things, we die. So first and foremost, we base our decisions on whether we have the necessities of life.

Once we have our basic needs met, we turn to safety. And in this stage, we find stability, which brings an order and calm to

MASLOW'S HIERARCHY OF NEEDS

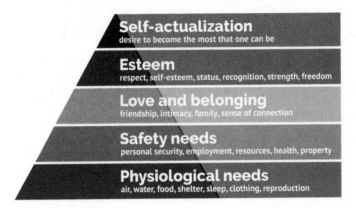

Self-actualization
desire to become the most that one can be

Esteem
respect, self-esteem, status, recognition, strength, freedom

Love and belonging
friendship, intimacy, family, sense of connection

Safety needs
personal security, employment, resources, health, property

Physiological needs
air, water, food, shelter, sleep, clothing, reproduction

our days. We have a job that helps us pay our bills, and we focus on personal care, like going to the doctor, moving our bodies, getting haircuts, and buying clothes. These things are also important.

Then when our lives feel safe and stable, we can start making our decisions based on the next tier: emotional needs. In this tier, we have love and belonging. We thrive on connection, so we need strong relationships with other people. Humans figured out pretty early on that we survive a bit better out in the wild when we work together, because someone else has skills that you don't, and vice versa. But we're also just *happier* when we have strong relationships. And we all know that happiness has a strong correlation to resilience and our ability to survive harsh circumstances a bit longer.

After relationships with others, we move to the esteem tier. How much do we respect ourselves? How much do we trust ourselves? Maslow's explanation of this tier also includes the esteem we receive from others, or rather, how other people regard

us based on what we've done. Do other people respect us? Do they acknowledge our efforts? (Spoiler alert: This is the tier where *confidence* comes into play, but we'll get to that later.)

Finally, if we have all our physical needs and emotional needs met, then we ascend to what Maslow called "self-actualization." That's where we put all the puzzle pieces together and start to reach our potential. I like to think of it as being my best self, filled with purpose as I walk toward fulfilling my mission on this earth.

So what does this have to do with a chapter called "Why Do We Care So Much?"

Look with me for a sec: Maslow put the esteem tier above the love and belonging tier. Both are important—that's why they're there. But to get to a place of self-actualization, when we're walking in purpose and on mission, we've got to master the esteem tier. And that means we need to like who we are and trust ourselves to act in ways that align with our faith, our values, and our flourishing. That's when we're confident in ourselves.

But to get to the confidence tier (aka the esteem tier), we must first master our relationships with other people. And here's the thing you need to know about relationships: God created us to be connected to other people. Remember in the garden when God said that it wasn't good for Adam to be alone? I wonder if God knew that Adam had a desire to be needed by someone else. Not just wanted, but needed. But God doesn't need anyone. So, he filled Adam's desire by creating Eve (#womanpower). It's the same for us. God created us to be needed and known.

I remember the first time I heard someone say those words. I was watching a church service, and the pastor said that, beyond food, water, and shelter, the two things humans need most are

to be needed and known (he's kind of right—just glance over at the hierarchy of needs). His words immediately resonated with me, awakening something deep inside me that felt so true.

*I **do** need to be needed and known, by someone and for something. I need to matter to someone.*

In his message, the pastor related our desire to be needed and known to our God-given desire to have a purpose, to feel like we were created for something and for someone. But we *have* to examine our motivations behind this desire.

When the Holy Spirit stirs our souls and says, "I gave you strengths and gifts for a reason, for my kingdom. Now get out there and use them," that's a healthy kind of motivation.

But just like with anything else, the Enemy can also use that stirring to make us want to be needed and known in an unhealthy way. Thinking back to earlier in the chapter (because I love a good callback), I believe Satan used Eve's desire for more in the garden. Because the serpent said to her, "God knows that when you eat [the forbidden fruit] your eyes will be opened, and you will be like God, knowing good and evil" (Genesis 3:5, NIV).

When the serpent said this, perhaps Eve heard, "You were created for more than this garden. Think about it. If you have knowledge of good and evil, you'll be like God, and doesn't God want that for you? Isn't that the goal, to be more like him? I bet he wants that for Adam too. You'd be helping him. Go on. Take it. Eat it."

That's the lie: that God needed Eve to help him.

So she did. She ate it.

And from that day forward, humans have s-t-r-u-g-g-l-e-d to remember that the only way to feel fulfilled is to believe we are

wanted and known by our God rather than working to be needed by God or our people.

..

To feel fulfilled is to believe we are wanted and known by our God rather than working to be needed by God or our people.

..

We want to be needed and known by someone. It's just human nature.

In kindergarten, I wanted to be needed and known by the mean girls who made fun of my drawing.

In middle school, I wanted to be needed and known by a group—any group. I wanted to feel good about myself, and the way to do that was by their approval. And to gain their approval, I transformed myself into whoever I needed to be so I could be accepted. It didn't matter if they were doing things I knew were wrong. If I was going to be approved by them, I had to do those things too.

By high school, my homelife had exploded and my only need was to feel loved. I gave my heart and my body to anyone who would help me feel that way.

By the time I was a wife and mom with three kids and another one on the way, I had no idea who I was. Was I the unloved girl, the popular girl, the girl who needed attention? I had no identity of my own, and I constantly looked to others to tell me who Ashley really was.

Perhaps you've been there, too: lost, lonely, caring way too

much what others think of you, and exhausted from trying to please everyone.

Sis, I can promise you this: You don't have to stay there.

Breathe, cry, feel seen, and know it's okay to want to be loved. It's okay to admit that you want to be liked by others, that you want to find belonging with other people.

So how do we have healthy relationships with others, where we're needed and known by them, while also making decisions that honor our values, our faith, and our flourishing? How do we have strong connections with others without people-pleasing and, instead, trust ourselves enough to walk with purpose on the path God has for us?

I've found the answer to those questions is *confidence.*

Building Your Confidence

DID YOU KNOW THAT WHEN YOU WRITE SOMETHING DOWN, YOU'RE using part of your brain that's linked to memory? That means when you write your thoughts or things you're learning, you're more likely to remember them. It's like puzzle pieces start to click in your brain. Pretty cool, right?[2]

So here's what we're going to do: At the end of each chapter, I'm going to invite you to think about what we talked about and give you a sec to practice some of the ideas. You don't have to show this to anybody or even tell them you're doing it. This is a zero-pressure way to get some of your observations down on paper and think about how you want to show up in the world. It's almost like you're visualizing who you want to be. And before you know it, what you practice on these pages will make its way into your everyday actions. Think of these as some baby steps toward building your confidence.

The Foundation

- Confidence comes when we like who we are and trust ourselves to act in ways that align with our faith, our values, and our flourishing.
- We're wired to please from our earliest ages. But we often misdirect this desire to please away from God (who has our best interests at heart) to other people (who maybe have motives that are a little less altruistic).
- Why does pleasing God matter? Because he wants us to flour-

ish. And he's set out principles for us to follow so that we can reach that place of flourishing.

- Having healthy relationships with others while staying true to our values is possible through real confidence.

The Tools

Spotting the red flags of people-pleasing. Wanting to be needed and known by others is okay! But when you're in a relationship with someone and wondering if you're acting out of a place of health or people-pleasing, look for red flags that show your focus is on the outside instead of the inside:

- Are you going along with someone else just to get along?
- Are you squashing the hurt you feel because you want to keep the peace?
- Are you apologizing for things that aren't your fault?
- Do you feel like you need someone else's praise to feel good about yourself or what you've done?

The Build

- Do you think the person you are on the inside matches the person you are on the outside? Why or why not?
- Think back to a time when you molded yourself to fit someone else's expectations. How did you feel in that scenario? Think about how your body reacted to that moment: shortness of breath, sweaty palms, racing heart. Now think about releasing that need to change yourself. How does your body feel?

- Take a look at the hierarchy of needs. Which tiers do you feel like you've mastered? Which tiers do you struggle with most? What might be the obstacle(s) keeping you there?
- Is there someone who helps you feel like the real you? Why and how do you think they're able to do that?

What Is Confidence?

> Blessed are those who trust in the LORD
> and have made the LORD their hope and confidence.
> They are like trees planted along a riverbank,
> with roots that reach deep into the water.
> Such trees are not bothered by the heat
> or worried by long months of drought.
> Their leaves stay green,
> and they never stop producing fruit.
>
> JEREMIAH 17:7–8

WHEN YOU THINK OF A CONFIDENT WOMAN, WHO COMES TO MIND? Take a minute to close your eyes and visualize her. Is she a friend, a sister, the CEO of your company, the PTA mom in the car line? I'll bet it's someone you know or see fairly often.

Usually we envision the woman who has it all together, dressed beautifully in her Pinterest-worthy outfit of the day. (Who doesn't love an #OOTD, amiright?) In fact, she looks amazing in everything she wears, whether it's a little black dress or shorts and a T-shirt. Her hair is cute, even if it's in a messy bun, and she walks and speaks in a way that says she knows who she is and she knows what she's doing. She fears nothing. She's not looking at the people beside her and what *they're* doing. She's laser focused on what lies ahead. And confidence radiates from her.

The woman I see has a big circle of friends, as well as a tight-

knit group of besties she can count on to hold her closest secrets. If she's a stay-at-home mom, she runs the PTA. If she works outside the home, she runs the company. If she works for herself, she has a massive social media following and makes a six-figure income while she manages her household and raises a family—seemingly without breaking a sweat.

Does this sound similar to the woman you pictured?

I know this woman.

I've tried to *be* this woman.

And this woman is exhausted.

Feeling good about who we are is often a constant exercise in striving, isn't it?

We tend to build our confidence on things like . . .

- how we look
- how involved we are in All the Things
- how our kids behave
- who our friends are
- the size of our social media following
- who liked our latest post
- how good our house looks when someone stops by
- how stellar our kids' grades are
- the work we do

And when we don't feel confident, we fake it. Because God forbid we should ever let anyone see that we *don't* have it all together.

YOUR CONFIDENCE FOUNDATION

The struggle to feel confident begins early in our lives. Our self-image is deeply rooted in the messages we receive in our early

childhood. According to a recent study by the University of Washington, researchers have determined that children's self-esteem is already established by the age of five.[1] Let me repeat: *the age of five!* Think about that. The way kids think and feel about themselves is formed before they ever set a tiny light-up-sneakered foot in a kindergarten classroom.

You know what this tells me? Our family of origin has the greatest impact on our self-worth in our early years. They are the first people who tell us who we are and how we measure up. They show us how to care for ourselves—or not. They show us how to speak kindly to ourselves—or cut ourselves down. They model how to trust and show affection to others—or reflect that the world is a place where it's scary to form attachments to other people. All of this feedback provides the foundation for how we think about ourselves and how much we trust ourselves and others. It forms the basis for the way we grow and develop our confidence later in life.

Our story evolves from our family of origin's stories—from our parents and grandparents and from the people who shaped their lives. Their stories provide the foundation for our story, good or bad, stable or not.

This is where my own story begins.

. . .

MY MOM SMELLED LIKE SWEET PEACHES AND COVERGIRL LIPSTICK. IT'S a weird thing to hold on to, I know, but there was something about her fragrance that made me feel safe. It was comforting. Scientists say the sense of smell has "a stronger link to memory and emotion than any of the other senses."[2] And to this day,

when I smell CoverGirl lipstick, I'm immediately drawn back to the time in my childhood that was sweet and innocent, when I was adored by a mother still capable of making me feel loved and protected.

For the longest time, I've kept a picture of her holding me when I was three months old. She was so young, only twenty-two, and she looked so happy, so captivating. I was her world, and she was mine. Even now, when I see her in that picture, I think about how beautiful she looked. And my heart aches because I know what's coming for us both.

Beyond those memories, there isn't much I remember about my mom that's comforting. She *tried* to be a good mom. I saw her try and fail and try and fail so many times throughout my childhood. But she was broken. And brokenness tends to trickle out to others in ways you don't intend.

At the tender age of three, she witnessed her father die by suicide. I can't imagine the psychological trauma that must have caused her. But mental health wasn't something most people thought about back then, certainly not in my mother's family. And that wasn't the only tragedy she suffered: My mom was abused by men when she was a child, leading her to ease her pain through self-medicating and self-destructing. Like many other girls who have suffered abuse, she sought love from anyone who showed her any affection, eventually getting pregnant as a young teen and giving that child up for adoption. She struggled to find her footing, to find stability and love.

My mother did find love, though, the kind that reaches past the pain and into the depths of your soul. Somehow my father's love made its way through her brokenness to the treasured part of her that longed to be loved.

But he wasn't a savior, at least not the one she needed. He left before I was born.

When I was growing up, my mom was with a guy named Ted. He wasn't my dad, not really, but I didn't learn this until I was thirteen. Ted knew, though, and he hated me for it. I represented a love that my mother would never have for him, a piece of her that he would never hold. And as Mom and Ted continued to have more children, Ted's hatred for me became more and more apparent. I didn't understand why he treated me so cruelly.

On the night of my thirteenth birthday, my grandmother drunkenly revealed that Ted wasn't my real father. I cried for show, but honestly, I was relieved. I'd always had a hunch Ted wasn't my dad. He was just so different with the other kids: strict but loving. To me, he was a monster, and knowing that I wasn't his child was such a relief.

As the evening of my thirteenth birthday progressed, I wanted to know more about my birth father. And because she was freed from a secret she'd been holding for years, my mom was all too willing to share the details. "I loved your father," she said. "He was so handsome, short and Italian." She went on to tell me how they'd gone to prom together, then eventually to college, and that she would never love another man the way she'd loved him.

Over the next few weeks, I fell in love with everything she told me about him. I hoped I had a father who was a good man, someone who loved me. I fantasized that maybe he just didn't know where I was, that he was out there trying to find me, and I told my mom as much. But that wasn't exactly what she wanted to hear. Tired of me romanticizing something that was so painful for her, she screamed out, "Ashley, your dad never wanted you! He gave me money to have you aborted!"

My father had wanted my mom, but he hadn't wanted me.

That's the story I was told for a long time, so I lived in a world where, in my mind, my dad didn't want me.* That deeply affected what I believed about myself for decades, becoming the foundation on which I would build my self-worth. I was a mistake, conceived by mistake and born a mistake. Unwanted, unloved, and fatherless. My mother, intentionally or not, had named me.

HE'S CALLED YOU

As children, we receive our identity from our family, specifically our parents. It begins with our name. Parents spend so much time deciding what to name their baby because it's foundational. As I'm writing this book, I can find about 380 baby-name books in one online bookstore alone. A name means something. A name is the start of our identity.

Our parents pour our identity over us. When you were little and your parents spoke your name, did you feel loved, cherished, championed? Or did they speak other names over you, ones that you didn't ask for?

"You're such a mess."

"If only you'd tried harder."

"Why can't you be more like your sister?"

"Stop being such a sissy."

"I knew you'd never amount to anything."

* When I became an adult, I learned the long and interesting *real* story from my dad. But I didn't know the truth back then.

If we receive false messages as children, they shape the false identity we take on as adults. When you grow up believing you're a mistake, *mistake* becomes your identity. It's the name you wear and the reason you believe bad things happen to you.

Good or bad, whatever we believe about ourselves shapes us into the people we become. What we believe about ourselves is not only the basis for our identity but also the measuring stick for our self-worth. And if we're measuring our self-worth based on the identity someone else has given us instead of what God says about us, our confidence will always be on a shaky foundation.

For the longest time, my identity was "I have no purpose because my existence is an accident. I'm a mistake. I shouldn't be here." *Mistakes don't get to be loved,* I told myself. *Mistakes don't have an identity. Mistakes just happen to exist.* I believed that I didn't belong anywhere and that if my own parents couldn't love me, because I was a mistake, then who would?

What do *you* believe about yourself? Maybe you believe you're not smart, pretty, lovable, wanted, worthy, talented, a good mom or wife or friend. Fill in the blank.

But hear me when I say this: Nobody gets to tell you who you are—not your parents, your partner, your friends, *no one*—because God has already declared who you are. And he did it a looooong time ago:

> Even before he made the world, God loved us and chose us in Christ to be holy and without fault in his eyes. God decided in advance to adopt us into his own family by bringing us to himself through Jesus Christ. This is what he wanted to do, and it gave him great pleasure. (Ephesians 1:4–5)

Let those words sink in for a sec.

Before he made the world, before he chose to do anything else, God loved you. He named you. He declared that you are his. And not only that—*he put you in his family intentionally.* And having you in his family made him so, so happy.

You never have to wonder who you belong to. Because you belong to your Lord. No matter your past, your parents, your family, or your struggles, you have an identity that is unshakable. You belong to your father, God.

CONFIDENCE REVEALED

So what does all of this have to do with confidence?

If we're being honest with ourselves, often we give so much importance to names and titles that aren't really ours. We let ourselves construct a self-image that is, at best, a beach condo built on a sandbar. It's just not going to last.

Confidence isn't built by making yourself seem important. It's not having the right job or leading all the right committees. It's not getting the most likes on social media or reaching a certain number of followers on TikTok or the 'Gram. It's not wearing the right clothes or the right size of clothes or being accepted into the right friend group.

I'm telling you a lot of things that confidence *isn't.* So what, exactly, is it?

Confidence is living as the capable, wholehearted person God made you to be. And how do you get to be this person? By trusting God when he says that your true identity comes from him. By believing him when he says that what he made is good and that he's equipped you with every single tool you need to handle whatever life throws at you. Real confidence means you

trust that, with the tools God has given and with him walking alongside, you can *and will* care for yourself well.

TL;DR—confidence means we trust God and we trust ourselves.

Confidence means we trust God and we trust ourselves.

Here's the interesting thing about confidence: A lot of people just leave it to chance. They think some people are born with it, some aren't, and that's just the way it goes. *But confidence can be learned.* It can be developed and honed when we adopt the true identity that God has given to us.

But to thrive in your true identity, you have to do something that's not super easy or fun: You have to make sure that the foundation your identity is built on is solid and sure. And that means examining what's holding up your confidence in the first place.

Did you just think to yourself, *Umm, I don't really want to go there right now*? Trust me, I get it. But when something was hard when you were little and you asked your mom why you had to do it, did she ever say, "Well, it's just one of those things"?

Well, sis, this is just one of those things.

UNDO THE FOUNDATIONAL LIES

I have a good friend named Darlene, and her parents divorced when she was young. Her dad remarried right away, and he and his new wife welcomed a few new children. Those kids became

her father's new family—to the exclusion of Darlene and her sisters. But that marriage didn't last long, and in just a couple of years, Darlene was the apple of her father's eye again. Until he remarried *again,* and Darlene ceased to exist in her father's world a second time.

This was a pattern that was repeated for *four* more marriages. With each new marriage and each new family, Darlene began to believe the lie that she wasn't worthy of her father's love. Surely there must be something wrong with her, or he wouldn't constantly need a new family with new children to love, would he? Darlene took on an identity that told her she was unlovable and that anyone who ever loved her would eventually reject and abandon her. Throughout her life, she looked for proof that she was being rejected:

- When she saw her friends post on social media about a girls' night she didn't know about, she suspected they'd been only pretending to like her.
- When the other moms on the baseball team all showed up with Starbucks, she assumed they'd all gone together and left her out on purpose.
- When her husband worked late, she *knew* he had to be cheating.
- When her son married and stopped coming home for Sunday dinner, he proved one of her greatest fears: that even her kids would someday grow up and abandon her.

Darlene's feelings of abandonment and rejection were so strong that she eventually pushed away a lot of people who loved her. But through a bit of counseling and a whole lot of grace, she learned the root of those feelings—her father leaving her

over and over—and it was like the scales fell from her eyes. She could see so many ways she'd been keeping people at arm's length and (falsely) seeing patterns of behavior that suggested someone was going to abandon her.

As those familiar feelings of rejection showed up, Darlene would take a second to examine the situation. Was it really as bad as it seemed? She also began to coach herself and speak to herself the way a friend would. She'd say things like, "In this moment, I remember that I'm the daughter of the King of the universe and I am so loved. These people love me—they're not rejecting me. I only *feel* rejected because of a past lie I've believed."

Reaching back to her past and thinking about the rejection she experienced from her father was painful for Darlene. But she realized that some of the pain she'd been feeling in the present was actually of her own making; she'd been distancing herself from others because she was afraid they were going to hurt her the way her father had: through abandonment. Darlene also realized that while she couldn't control what others did, she could control her reactions to those things. In situations where she felt triggered by perceived abandonment, she could choose to react with curiosity and compassion, instead of suspicion. She could try to remember that no matter what happened, she was a beloved daughter of the Most High and he'd give her whatever tools she needed to get through any situation.

Over time, Darlene has learned to abandon the foundational lies she'd believed about herself for far too long and walk in the confidence of Christ. Yes, it took work, but she was worth it. And so are you.

Take a second to think about your own foundation. Are you building your confidence on the shifting sand of other people's

actions and opinions and the names they've given to you? Or are you building your confidence on the rock-solid foundation of Jesus and what he's spoken over your life? The easiest way to know where you're building the foundation of your confidence is to examine the relationship you have with the person closest to you: *yourself*. Remember: Confidence is an inside job, so that means looking inward first, not outward to others. And you can see how strong this relationship is by how you speak to yourself every day.

SPEAK LOVE OVER YOURSELF

When you find yourself lagging or say something you wish you could take back, how do you talk to yourself? Do you coach yourself with positive thoughts or affirmations or even scriptures? Or do you talk to yourself the way I try *really* hard not to but do anyway sometimes:

> *C'mon, Ashley. Let's get this show on the road.*
> *Ashley, ugh, why can't you understand this? Are you that dumb?*
> *Oh my gosh, I can't believe you just said that.*
> *I bet she doesn't even like you; she just hangs out with you because she's a good Christian, that's what good Christians do, and she feels bad for you, a screwup.*

Yikes.

But here's a reality check: We're *all* having conversations with ourselves *all the time,* convos that no one else can hear. Your kids are doing it. Your husband is doing it. Your girlfriends are doing it. And I know what you want for them: You hope that what-

ever they're saying to themselves is kind and that they don't hold on to things like anger, resentment, or guilt for past mistakes. You hope they're so loving and gentle with themselves.

So why do we have such a hard time speaking this way to *ourselves*? I think it's because we're holding way too tightly to those false identities that others have given to us.

Listen to me: You are worthy of the gentleness that you easily give to other people. You are so, so loved—of course by your people but also by a God who's loved you since the foundation of the world. And there are so many ways he's shown that love to you, through word and deed:

- He's known you and stayed with you since your very beginning. In fact, he took his knitting needles and knit you together himself to make you one of a kind (Psalm 139:13–14). And ever since, he's called you his child (Ephesians 1:5).
- Just as a mama dresses her little one, God has tenderly dressed you in wonderful things. He's clothed you in salvation; he's draped a robe of righteousness over you. And on top of that, he's filled you with abundant joy (Isaiah 61:10).
- God has made you capable of remarkable things. In fact, he's made you more than a conqueror through him (Romans 8:37).
- In the most radical act of love, God sent his only child to become a human just like you—to show you he fully understands what it means to go through the hard things you'll go through: suffer loss, feel pain, and even die (John 3:16; Romans 5:8; 1 John 4:9–10).
- And just in case you ever doubted, he tells you directly: "I have loved you . . . with an everlasting love. With unfailing love I have drawn you to myself" (Jeremiah 31:3).

Look at how precious you are to God. Unique. Chosen. A conqueror. Draped in salvation and righteousness, drawn to him and wrapped in joy and love.

And if he speaks words like these over us, we need to do ourselves the courtesy of being kind to this wonderful person that God made and treating them as tenderly as he does.

If you believed in these names God has given you, how would that affect the way you see yourself? Knowing you're wrapped in love, what kind of mother are you? Knowing you're a conqueror, what kind of employee are you, even when you make a mistake? When you know you're precious and unique to God, you want a partner or friend to see you in the same way.

The words you use matter, especially the ones you say over yourself. And if you don't like what you're saying, change the conversation.

- **Place reminders of your true identity around your space.** Listen, I don't care what the haters say: I love word art. They're going to have to pry mine from my cold, dead hands, because there's no faster way for me to remember who I am than to see Scripture written out on the walls of my home. But you don't have to get fancy about it; you can put sticky notes of Bible verses or little phrases like "I am enough" or "I am loved" on your bathroom mirror, in your car, or even on your computer. Put them as the background on your phone so that every time you see your lock screen, you're reminded, "Oh, that's who I am!"

- **Speak words of affirmation over yourself.** You might feel a little silly about this at first, but that's okay! You don't have to speak these kind words aloud, if you don't want to. But know that there's science behind declaring these truths

over yourself: Researchers have found that affirmations acti-
vate parts of the brain connected to reward and can help you
deal with uncertainty and negative emotions.[3] When you feel
your brain sidelined by negative thinking, try saying truths
like these to yourself:

- ❏ It's okay to make mistakes; I'm just learning.
- ❏ I believe that I am capable and God has given me the tools
 to solve this problem.
- ❏ I deserve love and respect.
- ❏ I have been blessed with everything I need right now.
- ❏ With God, I am strong enough to get through this.

- **Reconnect through prayer with the One who knows
 you best.** There's nothing like spending time with someone
 who knows and loves you for who you are. If you need to be
 reminded of your true identity, sometimes all it takes to re-
 member is to say a quick prayer. Just that simple act of recon-
 nection reminds you of one part of your identity: You're
 God's child. And he loves you!

When you remember who you really are, when you speak
this kind of love over yourself, something interesting happens:
You start to think and live from a place of calm that you've never
quite had before. You feel secure in who you are. You know in
your bones that you can make choices that are good for you and
your well-being. Your foundation feels solid; your path feels
sure. Your insides begin to feel a bit more whole and healed.

Speaking truth over yourself, just the way God would, and
feeling your confidence grow is a wonderful place to be. I want
this for you so, so much. But I want you to keep your eyes open
about something: Building a foundation of confidence from the

ground up is hard. Your old identity that you've been holding on to since childhood or adolescence, or since some event in your recent past, may be so ingrained that even when you do the hard work of looking at your foundation and choosing to speak love over yourself, you may still mess up. You may say snarky things to yourself sometimes. You may dip back into the old patterns of looking to something other than your kingdom status for confidence. I know I have.

When that happens, stop. Just stop. Take a second to forgive yourself and remember your true identity. I bet you might begin to feel a bit more calm and secure.

Maybe you and your partner get into a fight—like, a *bad* one—and you're afraid this is it and he's going to leave you. But your confidence isn't built on how your relationship is going; it's built on Christ, the One who will never leave you. Remember: Christ chose you first.

When your friends go on a girls' trip without you, it could be easy to believe that you'll never have a close relationship with a friend, that it's too hard to be friends as adults. But your confidence isn't built on how many best friends you have; it's built on Christ. Wherever you are, he's there too. And he'll always be a shoulder to cry on and someone to celebrate with.

When your teenager tells you that you're a terrible mom after you take away driving or phone privileges, it could be easy to believe them, because you just want to make them happy. But your confidence isn't built on how much your kid likes you today; it's built on Christ. And he knows how hard you struggle to help your child thrive, even if that means enduring some seasons when the two of you don't see eye to eye.

I'll admit it: There are moments I'm pulled toward that old

identity, because sometimes it just feels easier to slip into choices that are familiar. Do you have a pair of jeans you keep around, even though they're a bit snug, but they've been with you for so long that you can't bear to part with them? Yeah, me too. But once you let go of those jeans and find something that fits a bit better, you'll breathe a teensy (or huge) sigh of relief, because wearing something that fits feels so *good,* even if it took a little effort to find it.

And you know what? The cool thing about our mess-ups is that God can still use them. So when they happen, sis, don't beat yourself up. Embrace them.

. . .

HOW ARE YOU FEELING? A LITTLE LESS SHAKY, A LITTLE MORE SURE? I hope so. There are things in our lives that will rock us to our core and threaten to topple us over: a diagnosis, a job disruption, an unexpected pregnancy, losing someone who's beloved. These events might change how we live our day-to-day lives, but they can never change who we really are. And no matter what happens, we can choose to remember, over and over, that we belong to God and he's declared that we are his beloved, chosen people.

So take those truths out into the world, no matter what your day looks like. Show everyone what a truly confident person looks like: someone whose life is built on the rock-solid foundation of God's love.

Building Your Confidence

The Foundation

- True confidence starts with believing that you are God's unique and beloved child, and that you are capable of loving yourself well, thanks to the tools he's given you.
- During the course of our lives, people give us names that don't match who we really are. But we can choose to do the hard work of removing those names and adopting the ones God has given us.
- Sometimes you may slip back into calling yourself names that don't apply to you anymore; you might be snarky or mean to yourself. That's so normal. Like Taylor said, just shake it off, sis!

The Tools

- **Abandon foundational lies.** You don't have to hold on to the names other people give you. With the help of Scripture and even a therapist, you can tackle the lies that have shaped the way you think about yourself and develop beliefs about who you are that are truthful, strong, and healthy.
- **Speak truth over yourself.** Whether you're putting a Bible verse on your lock screen, reciting affirmations, or saying a quick prayer, connecting with your true identity—who God says you are—is going to jump-start your confidence like nothing else.

The Build

- Write down all the names you received as a child, whether they were good or bad. Maybe someone called you "princess" or "sweetheart." Maybe "goofball" or "slowpoke." Or "too loud" or "too much." Whatever they might have been, write them down.

- Next, write down all the names you've received as an adult— again, good or bad, write them down.

- Now go back over each name you wrote down. Think about the positive ones that match who you are. Then think about the negative names. Ask yourself: Are they *really* true for you? Or are they descriptions someone gave you when you didn't act the way *they* thought you should?

- If you see identities that don't match who you are, hand them over to God. They don't belong to you. He'll put them in the garbage disposal for you.

- If you see a description that rings true for you but you don't like it, I want you to spend two minutes in prayer—just two—and hand those names over to God. Ask him to help you work through these things so you can turn those identities into ones that are more reflective of who you are as his family member.

- Finally, I want you to reflect on 1 John 4:4: "You belong to God, my dear children. You have already won a victory over those people, because the Spirit who lives in you is greater than the spirit who lives in the world."

- How does this verse make you feel about who you *really* are?

Coming to Your Own Rescue

> All you need to remember is that God will never let you down; he'll never let you be pushed past your limit; he'll always be there to help you come through it.
>
> 1 CORINTHIANS 10:13 (MSG)

I LIVE NEAR A HUGE NATIONAL PARK, WITH BEAUTIFUL ROLLING HILLS and deep forests with walking trails. I've hiked these trails with my family during the day, and while we've gotten lost plenty of times, I've never been super afraid. Even in the moments I wasn't *quite* sure where we were, I could see everything around me, and I knew we weren't too far from a ranger station. If we needed help, we could get it.

When I think about being on those exact same trails at night, I start to freak out. First, if you've never been to the woods at night, let me tell you: *It's creepy as all get out.* As the light fades and the darkness sets in, it feels like the entire world is being smothered by the deepest black velvet. The weirdest part is that you can't see *anything.* It's so dark that, even with your phone flashlight on the brightest setting, you can see maybe ten feet in front of you. Beyond that circle of light, good luck, sis. And every tiny sound you hear—some crunching leaves, a snapping

twig—means you're probably seconds away from meeting your Maker. If your brain is like mine, once it stops repeating a few choice words you won't let the kids hear, it'll start filling with all *kinds* of things that could be lurking in those shadows. Bobcats. Coyotes. Bears. Things that want to—I dunno—*eat me for dinner.*

Life is like those wooded paths at night. Try as we might, we can't see that far ahead. And I don't know about you, but if I had to rely on myself to get through that dark forest, I'd basically need to consider myself a bear's Pop-Tart.

But you know what? It's not all up to us—thank goodness. Because God doesn't let us move through these woods empty-handed. He's given us a backpack filled with tools we can use to make our way through the forest of our lives and not only survive but even thrive. We just need to reach into that bag and trust that whatever is in there is exactly what we need—and that he'll hand us anything else we don't have.

In some seasons, knowing that God's given you what you need to survive is easier to believe than in others. Believing this is especially hard when you've stayed in the woods too long by yourself because you thought that relying on yourself was the only way you'd make it through. And if you don't have any tools for the job, like a map or a flashlight, you're not going to get very far or you're going to take a wrong turn. You might, understandably, start to freak out. And if you're me, that means you start spiraling.

Ashley, what are you doing?
Didn't you already go this way?
What were you thinking, going out by yourself like this?
I knew you shouldn't have done it. I knew you were going to get lost.
You're out here all alone, and no one is going to find you.
You're stuck.

I don't know how many times I've spoken to myself like this—or worse—when I've felt lost in my life. And in those moments, sometimes it feels easier to sit down on a random stump and just stay there. For a while. Maybe forever? Or until someone comes to rescue you.

For the longest time, I waited for someone to rescue me. When I was little, I was sure *someone* would. Maybe my mom would sober up and start protecting me from my stepdad. Maybe my real dad would come back, or my grandma (who dealt with issues around alcohol) would get it together, and my life would be magically wonderful. I'd have the normal childhood I thought I saw other kids have, one where your mom picks you up from school and hands you a freshly made chocolate chip cookie still warm from the oven when you walk in the door and you go to sleep at night with no fear of what will happen to you in the middle of it.

I did find someone to save me. But my life didn't exactly turn out the way I'd hoped.

LOST IN THE DARK

On Friday nights in Gadsden, Alabama, when I was in high school, anyone who was anyone was at the skating rink. I spent about every Friday night there, and I *loved it*. I'd walk into the dark space, with the old-school disco ball sending flecks of light around the floor, and I'd be so *pumped* as I laced up my skates and glided toward the rink with my friends. We'd do laps and tricks and laugh, all while listening to the best soundtrack the mid-2000s had to offer: Sean Paul's "Temperature" and Rihanna's "SOS" but especially the song we heard *everywhere* at the time: "SexyBack" by Justin Timberlake.

Under the colored lights with the scent of popcorn and nacho cheese wafting in from the snack bar, the skating rink belonged to *us,* the teens. It was our place. And that's where I met Kayla.

She looked a little older than the rest of us, but I didn't register that at first. That night, I was wearing a rainbow choker, which I thought was super cute; I love anything with lots of color, and chokers were *in* around 2006. But what I didn't realize was my rainbow choker had a double meaning and flashed a signal that I hadn't meant to send.

"I like your choker" had been Kayla's opening line. I smiled. I always appreciated a bit of kindness, especially since I didn't get much of it at home. It didn't take long for us to become friends.

Over time, she became oddly protective of me. If a guy at the rink came near me, she put him in his place quickly and we'd all laugh about it as he skated off. She was so forceful that people were afraid of her. But that was okay with me. I'd found a bond with Kayla that filled a big hole in my life. She made me feel seen, protected, and wanted.

To me, life with Kayla seemed more enjoyable than life at home, where my mom cycled through addiction and sobriety, and my stepfather, Ted, lashed out at me verbally and physically. I did anything I could to disappear, to mentally check out from a homelife that was so unstable, from parents who did nothing to protect me. Kayla seemed to represent safety and security, a soft place to land in a world that had been so hard for so long. But what seemed like protection soon turned into something much, much worse.

What I recognize as an adult is that Kayla had a habit of hanging out with people who were younger than her—much younger. When I met her, Kayla was twenty-nine and I was only seventeen. Those twelve years, especially at our ages, spelled a

lifetime of experience that separated us. She had the fully formed brain of an adult woman. Although on the cusp of adulthood myself, I was still an underage teenage girl. There was so much I didn't understand. And I was just so vulnerable.

One night, we were partying at a friend's house. It was getting late, and we all went upstairs to go sleep in the attic, where, weirdly, there were a bunch of mattresses on the floor. To be honest, I was super high when I fell sleep. And the next thing I knew, I woke up and Kayla was sexually assaulting me.

She'd been working our friendship to lead up to this moment. "None of you touch her," I remembered her saying that first night at the skating rink. Now I knew why: She'd claimed me.

We had the most toxic relationship. I ditched my other friends so I could hang out with Kayla, and she began to show up wherever I was. If I was at school, she'd be waiting for me after the final bell rang. When I had a shift at the local McDonald's, she'd hang out at the restaurant. Eventually, she convinced me to move out of my parents' house and drop out of school.

Looking back, I can see that Kayla and I both got something from the relationship. I got a "protector," and she got complete control over me. And it wasn't good for either one of us.

Once I was out of my parents' house and out of school, I started to understand just how fully in control of my life Kayla was. What seemed like the love and protection I had always longed for became a living hell. Kayla was abusive and controlling, gaslighting me into believing she was the only person who would ever accept me for who I was. She even went so far as to have me beaten as a reminder that I would never escape her.

The person I thought would bring me freedom and security

was just one more person too broken to offer me any protection whatsoever.

That's when I realized how lost in the dark I was. And I wasn't sure how to find my way back to the light.

LIVING IN THE DARK

When we live in the light of someone else's approval, we are really living in the dark. But it can feel so good and so safe. It can start really innocently. You want to look cute for your partner on date night, so you wear that dress he's complimented in the past. You want your kid to think you're the coolest mom ever, so you let them stay up just a liiiittle bit later to keep playing *Fortnite*. You want the other moms to love you at your kid's soccer game, so you make sure to bring oranges and water to every game, even if you have to go out of your way to pick them up.

But sometimes chasing that "I need approval" feeling compels us to do something a little bit radical. If we go too far, we just might unknowingly make a deal with ourselves that says, "Instead of thinking about my thoughts and behaviors and if they're helping me grow into the person I want to be, I'm going to forget about that and let someone *else* tell me who I need to be. You know, to make *them* happy. That's how I'll be happy: if I make someone else happy."

Whew. That sounds crazy when you spell it out, doesn't it? But it's something we do more often than we realize. And it's happened to every one of us.

You know what's *really* crazy? When you give someone the stamp of approval over your life, you give away all the power and

agency that belong to you—that God has given you—and hand them to another person. You're essentially saying, "I don't want to take care of myself in a way that's good for me. I'm giving the say over what I do and how I think to you, Other Person. Have fun!" And, sis, that is so not fair.

It's not fair to that other person, even if they think they've asked for that responsibility. Because the responsibility to take care of you doesn't belong to them.

It's not fair to God, who has given you the tools, relationships, and other blessings you need to care for yourself.

..

You have an important job: helping yourself grow into the person God created you to be.

..

And it's not fair to you either. Because you have an important job: helping yourself grow into the person God created you to be (and the one you want to be!).

Listening to wise counsel from your loved ones and friends is important, of course. We get so much wisdom from listening to the stories of others! But ultimately, saving you from the dark isn't up to them. You need to *choose* to rescue yourself. I think that's why God gave us free will, after all. Because he knew that choice is powerful. Without the choice to opt in to a life of flourishing, the life God intended for us, we'd all be robots just marching along to our programming. And what would the point of that be? Choice gives our lives meaning. And choice gives us a *lot* of power.

OPTING IN TO YOUR OWN STORY

You know how we were talking about tools earlier? I bet I know one of the tools you use the most in your real life: Google Maps. Or Waze. Or Apple Maps (don't laugh—they've come a long way with Apple Maps, y'all!).

Isn't it hilarious how much we rely on these apps, even if we've been somewhere a million times before? I don't know about you, but I find it reassuring to know exactly where I'm going and take the guesswork out of what's ahead, whether it's an object on the road, a state trooper on the side of the road, or even an alternate route in case there's lots of traffic. These apps are souped-up versions of a GPS, which tells us exactly where we are on the globe and how to get anywhere we want to go. We have that kind of technology in our hands right now. Isn't that nuts?

I think God's given us a GPS of sorts: self-awareness. I like to think of self-awareness as our ability to take a step back and look at our choices so we can figure out, *Hey, is this where I need to be going? And if not, what choices do I need to make so I can get there? And what roadblocks might be keeping me from getting to that place?* That's important, right?

But a lot of times, we get too wrapped up in life to remember that we need to check in with ourselves. When we don't train ourselves to reach for that tool, sometimes we forget that our self-awareness GPS is available to us at all. Without even know-ing it, we start to drift off the path, unaware we're headed toward a destination we *definitely* didn't intend for ourselves.

There are so many times I've forgotten to take a step back and think about where my choices are taking me—like when I en-

twined my life with Kayla's. And I know I'm not the only one who's made a decision that led them off the path God intended for them, who got so lost in the dark that they couldn't see anymore.

Samson is kind of a big deal in the Old Testament. In a book dedicated to twelve judges of Israel (aka leaders of the Israelites before they demanded God give them a king), Samson takes up four whole chapters just by himself. You *know* that means he's got an epic story.

In Judges 13, we see that God had big plans for Samson from the time he was born. "You will become pregnant and give birth to a son, and his hair must never be cut," an angel said to Samson's mom. "For he will be dedicated to God as a Nazirite from birth. He will begin to rescue Israel from the Philistines" (verse 5). Ahh, the Philistines—Israel's biggest enemy. Things always get serious when they come into the picture.

As Samson grew up, his mother obeyed the angel who'd come to announce her pregnancy and never cut her son's hair. She and her husband, Manoah, tried as hard as they could to raise Samson according to the principles God set out for him. And because of this obedience, Samson was powerful. If someone tied up Samson with ropes, he could snap them as easily as if they were thread. He could rip apart the jaws of a lion—no sweat. He could pull up the gates of an entire town, hoist them onto his shoulders, and carry them away. His strength was the stuff of legend, and the Philistines knew it too. They stood no chance of conquering Israel if Samson stayed around.

For twenty years, this was the norm. While the Philistines remained powerful in the land, they could never *quite* conquer the Israelites. That is, until Delilah.

Word spread that Samson had fallen for a beautiful woman

named Delilah, and the Philistines hatched a plot. They promised her a ton of silver—I mean, the Bible says the Philistine leaders were like, "Delilah, we'll each give you 1,100 pieces of silver if you can pull this off," and we don't even know how many people came to her in that moment, offering that huge sum *each*. They said, "Entice Samson to tell you what makes him so strong and how he can be overpowered and tied up securely" (Judges 16:5). It's a little on the nose, but whatever. Shoot your shot, I guess.

Since the Philistine rulers had made Delilah an offer she couldn't refuse, she decided to go to her "beloved" and dig up some info. Samson must've had his antennae up, because he fibbed about the source of his strength—multiple times. He made Delilah look silly. She tied him up and wove his hair into a loom (for real), but when she said, "Samson, the Philistines are after you!" thinking his strength would be gone, he was able to get up and fight them off.

After getting humiliated, Delilah decided it was time to get serious and give Samson a DTR of sorts:

> Delilah pouted, "How can you tell me, 'I love you,' when you don't share your secrets with me? You've made fun of me three times now, and you still haven't told me what makes you so strong!" She tormented him with her nagging day after day until he was sick to death of it.
>
> Finally, Samson shared his secret with her. "My hair has never been cut," he confessed, "for I was dedicated to God as a Nazirite from birth. If my head were shaved, my strength would leave me, and I would become as weak as anyone else." (verses 15-17)

Oof. And there it was. Samson gave in to Delilah's wish to learn the secret of his strength instead of staying true to who he was supposed to be. He took his eyes off God's GPS. He could've told her no, even though he was "sick to death" of her begging him. But he didn't say no. And unfortunately, this one choice had quite the consequence. Because *this* was the info Delilah had been looking for all along. She immediately knew he was telling the truth. And of course, she told the Philistine rulers she'd learned Samson's secret. They were all so sure, in fact, that the Philistines went back to Delilah's house—and took the money with them.

Delilah lulled her man to sleep. Then she called one of the Philistines to come in and shave his hair. Once again, she cried out, "Samson! The Philistines have come to capture you!" (verse 20).

This, of course, was old hat to Samson. He thought to himself, *I'll just shake myself free.* But . . . he hadn't reached up and felt his hair yet.

It makes my heart hurt to think about what came next.

The Philistines were finally able to overpower the man who'd evaded them for two decades. They wanted to make sure he stayed subservient, so they blinded him. They took him to Gaza, put him in bronze chains, and forced him to grind grain in prison.

It's crazy to me to think that Samson, someone who'd been filled with so much purpose since birth, made a choice to put his relationship with a woman over everything else in his life. Over God, over his mission—all of it.

Samson had grown up with a solid foundation. His parents likely told him from the time he could toddle how special he

was, how worthy he was, how purpose-filled his life was. If someone like Samson could slip into pleasing someone else over following his God-given calling, then is anyone safe from falling into the same people-pleasing trap?

SHOWING UP FOR YOURSELF

The pull to please other people is powerful. Stepping away from our responsibility to care for ourselves in the ways that serve us and, instead, abandoning ourselves to please someone else is so tempting.

Whoa, whoa, whoa, you might be thinking. *I'm not abandoning myself. I still get up and brush my teeth and wear all the hats I'm supposed to wear. Sometimes I just want to make other people happy.*

Trust me, friend, I know your intentions are good. But that's what we people pleasers struggle with so much—often we deprive ourselves of what's best for us so that we can serve the desires of someone else. When we make pleasing someone else our primary goal, we're basically handing over the keys to our lives. We're handing them our GPS and saying, "*You* tell me where to go."

Sometimes it feels good to hand over the keys, doesn't it? When you've been at the helm of responsibility all day, for so many seasons, sometimes all you want to do is just let someone else be the adult and make the decisions for a while, because life is *hard*. And trying to go where you're supposed to every single day is exhausting.

- If you've brought a new little one into your family and you've found yourself drowning in a sea of diapers and breast milk

and spit-up and endless hours of *Bluey* (even though you love *Bluey*!) and deprived of so much of the freedom and calm and quiet you used to have, I know you're so overwhelmed.

- If you've been saddled with a big project at work and you've been rallying your team for weeks—or months—to put all the puzzle pieces together so your boss or client looks favorably on your work, if your laptop screen has been glowing in the late-night and early-morning hours far more than you'd like, I know you're burning the candle at both ends. And pretty soon you're going to be burned out.

- If you've been helping a parent navigate the hardship of aging, figure out Medicare forms, and fill prescriptions, if you're trying to make sure they're getting enough good food and mental exercise and moving their body to keep their muscles and joints strong, I know you're feeling every bit of your age and wishing your parent hadn't become more like your child.

- If you look around your holiday table and see an empty chair, no matter the reason that chair is empty, I know your heart is crying in grief and wishing you could do something— anything—to fill that chair again.

When it feels like the world is asking too much of us and we're not sure which way to go, it can be *so* hard to keep putting one foot in front of the other. But disengaging for a bit is easy. Disengaging may look like zoning out with some social scrolling or hitting Add to Cart a few times before going to bed. It might look like making sure you keep a stash of cookie dough balls in the freezer for emergencies. And popping one after another after another into your mouth while you binge-watch TV.

It might even look like sex. Or alcohol. Or drugs.

We all disengage from time to time. We're all looking for a

release at one time or another. But when you disengage from your life, you don't make your troubles go away. You're just putting them on hold for a while.

The big problem is when you keep disengaging because you're waiting for someone else to rescue you.

Well, sis, I hate to break it to you, but nobody is coming to save you. No one else *can* save you.

That is one of the *hardest* lessons we learn, especially as women. Because, from the time we were little girls, we read and watched stories that featured damsels in distress, waiting on strong men to come and save them.

I feel for the version of myself that believed I needed someone strong to save me. But the thing is, I already had Someone who could—and he was always there, offering me tool after tool to help me get through the dark forest. I just had to choose to accept his help.

One of the most powerful tools God has given you is something that is available to you right now: deciding to show up for yourself.

Showing up for yourself means that when things get hard, you don't disengage. You stay in the present, even though it's difficult. When someone else, like Kayla or Delilah, is pushing you to please them, no matter what the cost might be to you, you feel the agency to say, "No, that doesn't work for me. I'm not going to do that."

..

Showing up for yourself means that when things get hard, you don't disengage. You stay in the present.

..

You acknowledge where you are without judgment. You recognize that you're a human being who has wants and needs and that sometimes you're not going to know exactly what you need or how you're going to take care of yourself. But that desire to stay in these moments when you're uncomfortable and unsure of where to go instead of abandoning yourself and totally checking out—that's the key to showing up for yourself. Once you make a commitment to keep showing up for yourself, you reach into that backpack for the next tool God has given you: choosing how you're going to take action. And when you use that tool to walk confidently? Then God can work miracles—just like he did for Samson.

SHOWING UP WITH GOD

One day, the Philistines decided to have a festival for their god, Dagon, praising him for giving them victory over Samson. They decided to make a spectacle of their former enemy. They brought out Samson and put him between two pillars of a temple filled with three thousand Philistines so they could all witness the humiliation of this man—and make fun of him every step of the way.

But Samson had a minute to think while he was in prison. He realized how far he'd strayed from the path God had for him and chose to take action. He picked up his GPS and got back on the path to his mission. "O God, please strengthen me just one more time," he prayed (Judges 16:28).

And guess what? God showed *up* for Samson.

Samson moved his hands into position, lining them up on the pillars. And then, with all his strength, he gave the pillars one mighty *push*. Down came the roof, on top of him and the thou-

sands of Philistines in the temple. In one last feat of strength, Samson showed the mighty things that can happen when we step away from people-pleasing, when we decide to be faithful to our mission and come back to the center, to the path that God has for us.

So what does it look like to show up for ourselves? How do we start doing that in our own lives?

Great question, friend. Let's find out.

Building Your Confidence

The Foundation

- People-pleasing is something we all struggle with, and it's not going to save us in hard situations. But God's given us tools to navigate these moments while staying true to our flourishing and values.
- Show up for yourself, instead of disengaging from hard situations, to stay on the path God has for you.

The Tools

- **Self-awareness to take a step back.** Self-awareness is your GPS, helping you determine what's around you and how to navigate your path (and obstacles in it!) so that you arrive at your destination safely.
- **The ability to choose your actions.** This is one of the most important tools God's given you. Because, ultimately, your choices determine your path.

The Build

- Think about a time when, even though you were in a new situation, you felt totally at ease. Can you remember what your brain felt like? What were you thinking about?
- Now think about a time when you felt like you needed to do something to please somebody else. What did your brain feel

like right then? What were you thinking about? What were you worried about?

- Go back to that people-pleasing moment, and relive it in a way that feels like you're showing up for yourself a bit more. What would you do differently? How would you speak to that person?

Chapter 4

How to Show Up for Yourself

> What good is it, dear brothers and sisters, if you say you have faith but don't show it by your actions? Can that kind of faith save anyone?
>
> JAMES 2:14

I'M GOING TO GET REAL WITH YOU FOR A SEC. WE'RE FOUR CHAPTERS into this book, and I'm not sure I should tell you this or not. But you know what? I won't just talk the talk; I'll walk the walk with you. So here goes.

Right now, as I'm typing these words to you, I am legit *terrified*.

Is that okay to say? Are you going to shut this book and call me a fraud? Why on earth would you read a book about confidence from a woman who just told you that her fingers are shaking as she types?

Because, friend, that's what confidence looks like sometimes. I know—weird, right? I never would've thought so either. But here's something I've learned from my three and a half decades on this earth: Confidence isn't always pretty, especially when you dare to put it into action.

Twenty years ago—heck, even *three* years ago—if you'd told me a publisher would pay me cash dollars to write a book, I

would've laughed in your face. If I'd known the subject was confidence, I'm pretty sure I would've peed my pants from laughing so hard.

I never would've thought I was an expert on anything, but especially not confidence. I always thought confidence looked like Cady Heron in *Mean Girls* (aka Lindsay Lohan's character) when she started hanging out with Regina George and the Plastics, strutting the hallways in her heels and cool clothes, with everybody talking about how cool she was. With that kind of swagger, it seemed like you could do *anything.*

I thought confidence looked like Meryl Streep in *The Devil Wears Prada,* the way her character, Miranda Priestly, ran a successful fashion magazine with hundreds of people looking to her for opinions while someone made sure to take her coat and get her steak and anticipate her every need. How could you *not* be confident with so many people looking to you for answers?

Maybe, I thought, confidence looked like Michelle Obama, Serena Williams, or Madeleine Albright—women at the top of their fields with amazing careers and families. Surely this was confidence: having it all in every sphere and having people look up to you.

And it's true—confidence can come from that kind of success. But most of the time, it's way less grand. Because, most of the time, confidence doesn't shout. It whispers.

I know you're tired, it says. *I know you feel lost. I know you've tried so many things. But maybe, just maybe, you can try again. Maybe try this new thing. Put one foot in front of the other, and keep going. See what happens.*

I never thought I could write a book. Ever. But I'm doing it. One page, one line, one word at a time. All because I'm choosing to listen to the whisper that says, *Just try one more time.*

Confidence doesn't always mean you have everything figured out. It just means you're willing to try something new, something different, and you know that no matter what happens, you're going to be okay. You're going to show up for yourself and figure out the next step.

That's what I learned in one of the most pivotal moments of my life.

JUST AS I AM

Some stories have more twists and turns than a winding mountain road (or even a Stephen King novel). The story of how I became a mother is similar. There are so many bends in the road I can't include, because I want you to stay with me for the journey. So forgive me as I fast-forward through some of the details. I assure you, you'll get the gist of what I was going through by what I'm able to tell you.

. . .

I WAS TWENTY YEARS OLD. I HAD A NEW BABY. AND I WAS SO SAD.

The past few years had been filled with more attempts to find out who I was. Remember how tied up I'd been with Kayla? We ended up moving into her mom and stepdad's house, and she continued to control who I saw and who I could talk to. That wasn't great. But there was one person she *did* feel comfortable letting me talk to, and that was her brother Derek. And I liked him a lot. It didn't matter that he was a good decade and some change older than me; it just felt like we had a lot in common.

At that time in my life, Derek was my only friend. But I'm glad he was. We'd play video games at night, and he was such a good listener. For the first time in a long time, it was like someone actually saw me for who I was—and actually liked me for me, even with my suitcase full of family baggage.

Derek became a portal to the outside world, a place beyond Kayla's grasp. I felt like I'd finally found someone who might *really* be able to save me.

Eventually, I found a cheap apartment so I could have a bit of independence. Kayla moved in with me, and guess who else did? Derek. At this point, we were still just friends. But I started to see that he wanted something more. Something physical. I didn't want it, not really. But once again, I did what I felt like I had to do to stay safe. So I shut myself off and tried to please him. My new savior.

After several months of living in constant fear, I knew I had to leave Kayla. There was only one place in Gadsden where Kayla wouldn't mess with me: my parents' house. The thought of ever going back there made me sick, and I couldn't believe I was even considering it. I told Derek that I wouldn't go without him. Once we'd spent some time discussing it, my parents agreed to let Derek move in—he was going to pay them rent, so that probably made the decision easier for them. I was finally free from Kayla but hooked on Derek's protection.

. . .

LONG STORY SHORT: AT NINETEEN, I ENDED UP PREGNANT. DEREK WAS the father.

Around that time, I was in one of the more stable periods of

my life—at least it felt that way at the time. I had one of the best jobs I've ever had, as a server at Cracker Barrel. And I was *good*. So good, apparently, that it showed to the higher-ups.

One day, a few Cracker Barrel execs came to our restaurant just to watch me work, and by the time they left, they'd offered me a job: They would send me around the country, all expenses paid, to train other servers. As they finished their offer, I beamed with pride. "Yes, that would be amazing! I'd be so honored!" I said. I was so thrilled, I could hardly get the words out. New baby on the way, great job—the next chapter of my life was going to be big and exciting.

When I was about four months along, I started to think about everything I'd need to make sure my baby thrived when they arrived. I figured I needed a car. I'd saved up some cash from Cracker Barrel, and I was talking to my mom and stepdad. They had a car they weren't using, and my mom said, "If you just pay to get it fixed, you can have it." This seemed like a pretty good deal, so I agreed.

And my stepdad held up his end. He ordered the part, and he fixed the car. When I asked my mom for the title—you know, the piece of paper that says you actually *own the car*—she slammed the door in my face. Then she told me she'd lost the title.

And for good measure, because my mother was jealous that Ted had taken the time to fix something for me that he'd never fixed for her, she kicked out her child who was nineteen years old and pregnant with her first grandbaby.

I was devastated.

I'd given away thousands of dollars I'd saved up for this car. Now I also had no home. So I did what I needed to do for my child: I called Derek.

Derek had spent some time living near the Outer Banks of

North Carolina, a ten-hour drive from Gadsden, and he had a job waiting for him there if he wanted it. I didn't love Derek, not really. We fought plenty, and I'd often catch him lying about things. But I felt like I needed a protector, and I wanted our baby to have what I never did: a mom and dad who could really be there for them. So I decided to make a go of it with Derek in North Carolina. I quit my job at Cracker Barrel (I know—I was so sad, and so were my bosses). And Derek got me and my stuff, packed a U-Haul, and took me and our baby-to-be to North Carolina.

Derek's job kept him out of the house a lot, especially since it was two hours away. And I knew exactly no one in this town. I didn't have a job. All I had was Derek, my doctor's appointments, and, pretty soon, my beautiful, perfect baby boy, Braiden. And while I loved spending time with Braiden, those first few months of his life were hard. I had a new baby and approximately zero people to help me care for him in a sea of feeding, burping, changing, and crying. Derek had to get up super early and came home late from a long commute; he was zonked by the time he came home. When I'd ask him for help or tell him how frustrated I was, he'd storm off to check out and spend another night getting high with his dad. There was so much lying, so much drug use, so little help. I was alone, depressed, and desperate.

My self-awareness GPS started to flicker because I knew I wanted something better for myself and Braiden. But I didn't know which step to take next, and I didn't know how I wanted to move forward.

. . .

THERE'S SOMETHING THAT HAPPENS WHEN YOU BECOME A PARENT: You become more of who you were before you had kids. Every thought, every dream, every fear you've held on to—all of it gets amplified in a way few are prepared for. For me, this came out in two ways. One, my need for a savior felt stronger than ever. And two, my desire for something better grew fiercely within me.

One Sunday, when Braiden was six months old, an appetite for something I couldn't name started growing in my heart. So I got my son dressed, and out the door we went.

I'd driven about ten minutes down the road when I saw a church we passed by every time we went to the store. It was called Cabin Swamp Church of Christ, a little brick building nestled in the trees just on the edge of town. I checked the time and knew we'd be late for the service, but for some reason, God was drawing me there in a way I couldn't explain. I decided to just listen to him for once. Maybe this was Braiden's something better—and my own. I chose to do the brave thing and show up for us: for my son and for myself.

Let me tell you something: Church has always felt like home to me. As a little girl, when things were even crazier than usual at our house or when the abuse was worse than I could cope with, I'd run to the nearest church. I always knew that when I walked in, there'd be somebody who was happy to see me. I still remember some of the faces of the Sunday school teachers I had growing up—caring, full of kindness. I'd sit in awe as they told us about Noah and the ark, Moses and Egypt, Joshua and Jericho, David and Goliath. In each of these stories, they talked about Someone else, Someone who loved me more than my mom or dad ever could. They told me about God. In every Bible story they told, God was the hero who came and saved his people. And that day, I needed saving.

As I drove closer, I was filled with a mixture of excitement and nerves. It had been years since I'd been inside a church, and the fact that I was going back for the first time as an unwed mom wasn't making it any easier to walk in the doors.

I pulled into the grassy parking lot, soft and muddy from recent rain, and stopped the car. My hands were sweaty, and I started breathing heavy. I couldn't go in: As soon as I stepped into the foyer, they'd *know* I didn't belong there. They'd know immediately I wasn't one of them. I started to put the keys back in the ignition when I heard Braiden babble from the back seat. I looked at him in the rearview mirror and remembered why I was there in the first place. I breathed in deeply and prayed a simple prayer: "Help me, Jesus."

I got Braiden out of his car seat and headed up the stairs toward the white front doors. I opened the doors, and there, seated in red pews, were twenty or so people who all seemed to turn around and look at me at the same time. I felt like Mary Magdalene walking into their church, and if it had been only me, I might have just turned around and left. But I was there *with* Braiden, and I was there *for* Braiden. I was determined not to turn back. I found an open seat near the back and quickly sat down.

Nothing crazy happened that day. The service ended; I shook a few hands; then we hopped back in the car and left. But when you live in a small town, news travels fast, and you aren't as anonymous as you might think you are.

The following week was Thanksgiving, and on Tuesday, there was a knock on our door. I wasn't expecting any company. I looked through the peephole and saw a kind young woman I'd met at church. I panicked. How had she found out where I lived?

She smiled as I opened the door, and she was holding a brand-new outfit for Braiden, a cute little onesie she'd seen while shopping that day. I couldn't believe we were receiving such kindness. As she walked back to her car, she flashed another smile and said, "It was so nice seeing you at church. Will we see you again this Sunday?"

I smiled back as best I could and told her that I would absolutely be there, while having zero intention of ever walking through those doors again. She drove off down the dirt road, and I looked at the outfit. I thought about how this woman went so far out of her way to give Braiden this present, and even though I didn't want to, because fear of rejection is *powerful,* I knew I had to give Cabin Swamp one more try.

The next Sunday, I got myself and Braiden dressed. I put him in a super cute duck outfit (because babies + ducks = adorable), and I managed to get us out the door. This time, we weren't going to be late. We pulled into the parking lot around the same time as everyone else, and I walked into church like I'd done it every week of my life.

As the service drew to a close, I walked up the aisle. I meant to simply bend down and pray, like I was used to doing in other churches. Little did I know, I'd responded to an altar call, though normally people in this particular church would simply raise their hand if they wanted to talk to the pastor. Oops!

The pastor came over, and I spilled my guts to him. I told him about Derek. I told him I was desperate for something better. I told him I wanted Jesus but I wasn't like everyone at that church. I had a past. I'd made mistakes. I was from a deeply broken home, a product of abuse. How could Jesus love a sinner like me?

As the tears streamed down my face, I gave every reason Jesus

couldn't love me, as much as I wanted him to. Plus, I thought there was a laundry list of things I had to do before I got baptized. I thought I had to know the Bible front to back; I thought I had to be a member of the church. But the pastor shook his head and said, "Jesus loves you, Ashley. He loved you when you didn't even know you needed him. Jesus wants you, and he wants to give you a new life that can only come from him. Do you want that too?"

I looked through my tears at Braiden and nodded, unable to speak at that point. The pastor had me repeat a simple prayer with him, and in a moment, I knew what had been drawing me to Cabin Swamp this whole time. I realized that Jesus was the one running after me, calling me by my name, drawing me toward him. He was ready to receive me with the love I'd always been looking for. I'd found my Savior, and my Father had found me.

A GOD WHO STAYS WITH YOU, NO MATTER WHAT

Sometimes confidence doesn't start from a flame that's burning inside us, from a desire to make ourselves better. Sometimes it comes from a desire to make things better for our loved ones. Sometimes it starts with a question that spirals into another question, then forks into a few more unexpected paths. That's okay. There are so many roads that'll get you to confidence.

Maybe you'd like to go back to school for a degree that'll help you take the next step in your career—or switch careers entirely. But you haven't been in a classroom in a *long* time, and you're not sure you can keep up with the younger students, how you're going to afford it, or if your friends and family will suffer because you won't be around as much.

Maybe you'd like to start your own business so you can have more control over your schedule. You'd love to have margin in your life to be Room Mom and even your son's T-ball coach. But you have no idea what it even *means* to start a business. What paperwork do you need to file? How will this affect your taxes? Are you going to be wasting that nest egg you have tucked away for emergencies? And do you have what it takes to succeed, or will you fail?

Or maybe you've been sitting in your church pew with an uneasy feeling for a while. You love the people you worship with, but you're starting to realize you don't agree with everything this body of believers thinks is important in the way they practice their faith. You're thinking about uprooting yourself and finding a new church. But you're not sure where you'd go, and you don't want to make waves, especially because some of your closest friends go to this church. You wonder if it would just be easier to stay in that pew and keep your mouth shut.

I'll be honest: Standing in front of a roomful of church people and saying, "Here I am, y'all, broken and bruised," then just waiting to see if they'd love me anyway was hard. They could've easily said, "Sorry, but you're just not like us, and we'd like you to leave." But my desperation for a better life for Braiden and myself turned into a bravery I never knew I had. So I showed up for myself, and, sis, God turned that desperation into deliverance.

Standing up for ourselves is hard, especially when we put everything on the line. Is it worth taking a risk when we don't know how—or if—God will show up? How do we know that we can trust him and count on him to help us? How can we walk in confidence with him? Because he's given us tools to pull out when we find ourselves in these hard places. He's given us

stories that remind us what he's done in the past and how he's capable of showing up for us in the present. After all, he plans to prosper us and not harm us, like he tells us in Jeremiah 29:11. When everything is on the line, that's what I choose to believe. That gives me the courage and confidence to take the leap, knowing he's going to catch me.

. . .

REMEMBER DANIEL OF THE LION'S DEN FAME? DO YOU REMEMBER *why* he was put there in the first place? Let me jog your memory. We're going to go *way* back, five hundred-ish years before Jesus.

So when this story came into play, God's people weren't actually *in* Judah, their homeland—they were in the land of Babylon, where they'd been prisoners for decades after their land was captured and their temple was destroyed. When someone takes you away from your homeland and destroys the very place that gives you physical and spiritual identity, it's hard to remember who you are and where you're going. You'd completely understand if the people of Judah had forgotten about the God who'd brought them out of Egypt and into the promised land, which had been taken away from them. You could understand why they might feel like he'd forsaken them.

But Daniel didn't forget. Not for one minute.

He had been a member of a noble family of Judah, and when God's people were captured, Daniel was placed into service in the palace of Babylon because he was smart and educated enough to be useful. He was then trained in the language and literature of Babylon—in fact, the Bible says that God gave him and his three companions also selected for service (do Shadrach,

Meshach, and Abednego ring a bell?) "an unusual aptitude for understanding every aspect of literature and wisdom. And God gave Daniel the special ability to interpret the meanings of visions and dreams" (Daniel 1:17). They became so good at their jobs that the king realized no one in his kingdom—no magician or enchanter—could provide him with as much wisdom as these four. They became super valuable to the king.

But what if you were one of those magicians or enchanters who'd been the king's go-to years before? I bet you can imagine how it must've felt for the king to be so into these new dudes and all their talents. The short answer is *not great*.

The other kingdom officials were jealous of Daniel, who was about to be appointed to a huge position to help oversee the entire Babylonian Empire. They tricked King Darius, the ruler at that time, into making a law: Anybody who prayed to anyone—human or divine—instead of *him* during the next thirty days was going to be punished by being thrown into a den of lions. P.S.: This law couldn't be changed or revoked.

It didn't take long for Daniel to hear about this new rule. But the Bible doesn't say that he had a hard time with it. He didn't freak out. He just stuck to his normal routine: He went to his room, opened the windows, and prayed. Three times a day. Daniel wasn't going to stop because the king's law told him to. He could've closed the window—but like the baller he was, he didn't. I think he *wanted* people to see that he wasn't afraid. Man, was he confident that God would show up to protect him.

Of course, people saw Daniel praying like he usually did. And like the petty tattletales they were, those jealous officials went to the king and told him about Daniel.

Instead of getting upset, Darius got so sad and kept trying to figure out how to save Daniel. But that pesky "you can't change

this law" clause got in his way. He couldn't think of a loophole to save his trusted employee.

So with a heavy heart, Darius gave the order for Daniel to be arrested and thrown to the lions. As Daniel left, the king mournfully cried out, "May your God, whom you serve so faithfully, rescue you" (6:16). And to add insult to injury, they rolled a huge stone over the entrance so Daniel couldn't get out.

The next morning, the first thing Darius did was run to the den and call out to Daniel, hoping he was still alive. "Daniel, servant of the living God!" he shouted. "Was your God, whom you serve so faithfully, able to rescue you from the lions?" (verse 20).

He got the best surprise when Daniel called back to him and confirmed that, yes, he was alive because God had closed the lions' mouths.

There are so many stories of people stepping out in faith like this, confident that God was going to have their backs. I think about Queen Esther, who pushed past her fear, went before the king, and asked him to save her people, even though she risked being put to death for such an action. She saw that confidence in God, no matter the cost, will bring you peace even in the direst circumstances. I think about more modern heroes, like Mother Teresa, who cared for the poorest people in the world, sometimes putting herself in harm's way so that she could show her love.

I could go on and on. But . . . sometimes these stories don't have a happy ending, at least here on earth. I know you've read about the fates of so many apostles who died because they dared to share about the faith that meant so much to them. I say that not to be a bummer but to remind you that even when your story is hard, even when it feels like the ending isn't a happy one, God hasn't abandoned you. He's still with you. And when you're

not sure what the outcome is going to be, you can carry the peace that comes with moving through the world as a child of God. Because he'll never leave you or forsake you.

A COMPASS FOR YOUR PATH

Knowing you're supposed to do something new or scary is *hard*. But when the time comes to actually do that thing? Taking the first step can feel nearly impossible.

But that's the thing about life: God gave you free will, the ability to choose how to act. Remember what that means? While you can't control what happens to you, you *can* control how you choose to act when it happens.

And you know what makes it a whole lot easier to choose how to act in any given situation? Having a mission.

..

You know what makes it a whole lot easier to choose how to act in any given situation? Having a mission.

..

You can see it in the stories I just talked about. Daniel, Queen Esther, Mother Teresa—they all had a mission to honor God in whatever life threw at them. Over and over again, even in the worst circumstances, having a mission is going to remind you of your *why* so that you keep pressing forward.

So what is a mission, anyway? I think it's how God can use us as an instrument for good in the world.

Thinking back to my own story, I see I had a mission as a new mom, even if I wasn't totally aware of it at the time: My mission

was to make sure I was giving my son the best life that was available to him. Now my mission has expanded a little bit, because it includes you! Not only do I want to help my family be physically and spiritually healthy, but I also want to share my story and what I've learned with other people so that they don't have to wander off the path or stay stuck in the same ways I did. I want to help them realize that they're not alone and that God has given them tools they can use to navigate to a place of fullness and flourishing.

Your mission is probably going to look different from mine. It'll look different from your parents', your partner's, your friends'. And that's okay! In fact, God designed it that way. I love the way *The Message* talks about it in 1 Corinthians 12:7–11:

> *Each person is given something to do that shows who God is: Everyone gets in on it, everyone benefits. All kinds of things are handed out by the Spirit, and to all kinds of people! The variety is wonderful:*
>
> *wise counsel*
> *clear understanding*
> *simple trust*
> *healing the sick*
> *miraculous acts*
> *proclamation*
> *distinguishing between spirits*
> *tongues*
> *interpretation of tongues.*
>
> *All these gifts have a common origin, but are handed out one by one by the one Spirit of God. He decides who gets what, and when.*

See what I mean? God gives us different gifts for different missions. And so often, your gifts and characteristics can point you to your particular mission.

Maybe you're really good at explaining complex ideas. Maybe your mission is to be a teacher, reminding the little ones in your classroom that they're seen and loved as you help them master new skills.

Maybe you're a great communicator who has a heart for others in need. Maybe you could get a job in marketing for a nonprofit, and your mission is to communicate the needs of your clients to the people in your community so that the community can take action and help your organization.

But maybe your mission isn't tied to your profession at all; in fact, maybe you've always wanted to be a good mom to your kids. I can't think of a better way to do that than to teach your kids about Jesus and tell them how they can show his love to their friends and neighbors.

Maybe you have more than one mission—that's okay too! Like the Bible says, "the variety is wonderful."

And let me tell you what happens when you have a mission: There's a peace that comes when you're acting with your mission in mind, even if you don't know where it's going to lead. When you act according to your mission, you act with *integrity;* that's when your outsides match your insides. And integrity is rocket fuel for confidence, because when you know who you are on the inside and can rely on yourself to carry it out on the outside? You trust yourself, and you are unstoppable. When you trust yourself, you know that when things get hard, you and God will be able to tackle whatever comes.

Because it's not a question of *if* life gets hard—it's *when*.

Building Your Confidence

The Foundation

- You can't always choose what happens to you. But you *can* choose how to respond to what happens to you—with the confidence that God will *always* have your back, no matter what.
- When you're lost and not sure how to navigate out of the dark, remembering your mission will help you choose the next right step.

The Tools

- **Cultivating a mission.** Your mission acts like a compass—it points you in the direction you'd like to go.
- **Stories of past heroes.** Read about other people who have faced difficult decisions like you have, and see how God came through for them. Then remember: God is the same yesterday, today, and tomorrow. He has your back too.

The Build

Don't have a mission or are a little foggy about it? No worries! I'll ask you some questions to help you chip away at it and find yours.

P.S.: It's okay if your mission changes over time. Because that's how life works—priorities shift, based on the season.

- When you get out of bed in the morning, what's the energy that drives you to pull off the covers (besides coffee)? What are you most looking forward to doing that day?
- Why do you think the thing that got you out of bed is so important to you?
- Take a minute and think about this one—it's kind of deep: What kind of person would you like to be? How would you like for other people to describe you if you weren't in the room? I know this one's kind of tough, so I'm going to give you a few suggestions. Feel free to circle as many of these words as you'd like, but if you keep it around three or four, you'll see which character traits matter most to you:

Kind	Honest	A teacher
Courageous	Selfless	Always learning
Fun	A leader	Committed
Focused	Hardworking	Inclusive
Respectful	Wise	A tough cookie
Consistent	Patient	Filled with integrity
Generous	Poised	A good listener

How do you think God could use that drive and these characteristics to do good things?

PART II

Confidence Killers

Chapter 5

The Lowdown

> Be strong and courageous! Do not be afraid or discouraged. For the LORD your God is with you wherever you go.
>
> JOSHUA 1:9

ALLOW ME TO BLOW YOUR MIND FOR A SECOND.

Think about the first two hours after you get up every day. What are those like for you?

If you're me on a regular ole Tuesday, here's what that looks like:

- I get out of bed. Congrats, Ashley.
- On the best days, I go read my Bible or a devotion in the quiet of the living room. On the days when I'm hurrying around, I might scroll through a devotional email while I'm still in bed. (Just keeping it real, y'all.)
- I go shower, dry my hair, put on makeup and some clothes, and hit the kitchen.
- I make breakfast for me and the kids; sometimes my husband, Doug, has already made it since he leaves earlier than me and

he's a saint. It might be eggs and toast; it might be a smoothie—whatever.

- I make sure all the kids have everything they need for school: backpacks, lunches or lunch money, homework folders, books, notebooks—all of it.
- If we're lucky, we make it in time for the bus to pick up the kids on our street. If not . . . we're hitting the drop-off lines.
- I come home and get to work. Some days, it's filming TikTok videos. Other days, it's coaching clients. The days I'm *really* on top of stuff, I'll fit in a twenty-minute workout. My work varies, which keeps things fun and fresh. I love it.

Okay, that's just the first couple hours of the day. Your morning routine may not look *exactly* the same as mine, but I bet it mirrors at least a few things.

Twenty years ago, maybe even ten, how much of your current morning routine was part of your day? How many of these things did you even know how to do?

It's crazy to think about how much has changed, isn't it?

Twenty years ago, I'd never been a mom. I didn't know the thousand steps it takes to make sure my kids get up, get dressed, eat *something,* and have what they need for school before I corral them into the car like a herd of chickens. It's something I learned how to do over time—which means I learned what *not* to do the hard way and figured out how to avoid meltdowns (from my kids *and* from me). Most of the time, anyway.

When I was younger, I didn't know all the cute ways to style my hair. I didn't have makeup tutorials to show me how to fill in my brows or Instagram Reels from dermatologists telling me why vitamin C serum is *soooo* great for brightening your face (it

really does work, y'all!). As far as cooking went? Pssh—I could burn toast with the best of 'em.

The things that come so easily to me now are things that, at one point in time, I had no clue how to do. But over time, I learned. I took notes. I thought about what felt good and what didn't and how to adjust different parts of the day so that things could go more smoothly for us as a family.

We humans are good at learning things—that's the way we're wired. We pick up on what's helpful to us and rework the things that aren't. Over our lifetimes, we cultivate a variety of skills that help us succeed at work, at home, in our relationships—everywhere. And lucky for us, confidence is one of the skills we can learn, sharpen, and have available whenever we need it.

Having confidence might come more easily to some than others, sure. But in my heart, I *know* that confidence isn't something that's gifted to some people and not to others. Anyone can cultivate confidence. It just requires a little bit of practice.

But what if you're a pretty confident person already? What if you've got your life, your routines, your goals, dreams, and relationships, and you're feeling great right now? What if everything's firing on all cylinders? What if you think you don't *need* any help with confidence?

Allow me to take you on a quick detour to the great outdoors.

Have you ever gone fishing? It's one of the most relaxing things you'll ever do. Sometimes it's hard for me to fish for hours on end because, hello, my name is Ashley and I have a hard time sitting still, waiting for a fish to take the bait. I've been guilty of being on my phone more than a few times while my pole got a nibble. It's not my fault that fish aren't funny and

can't do TikTok dances! Maybe I'd pay closer attention to the pond if they did.

Doug absolutely loves to fish—he's pretty good at it since he's much more patient than me. His idea of a great day is getting up early in the morning, when it's all quiet and misty, taking a fishing pole and some bait, and parking himself on a boat or by a stream for a few hours to see what he can catch.

I've gone with Doug quite a few times at this point, and it's interesting: We may hit a fishing spot one day and catch ten fish, one right after the other. It's crazy! But if we went to the same spot the next day, we wouldn't catch a single thing. The first time this happened, I couldn't believe it—how could we be so successful one day and have such a dry spell in the *exact* same spot with the *exact* same pole and the *exact* same bait the next day?

"Sometimes it changes, the way fish bite," my chill husband tells me. "What works for you one day may not work the next. The most important thing to do is just keep trying. They'll bite again."

What works for you one day may not work the next. The most important thing to do is just keep trying.

He's a wise man, my husband.

Let me remind you of something you already know: Life changes. It's the one thing that's guaranteed. Life as you know it today isn't always going to look like this. The roles you have will change. Heck, *even your face will change.*

So in the face (no pun intended) of so much change, how do you keep your confidence intact? How do you remind yourself that you can weather whatever comes and move through it with grace? How do you keep the faith to keep trying, instead of cutting the bait and turning back?

You replace "perfect" with "good enough," accept that change is going to come, and vow to keep on trying to stay true to your mission. And you keep your eye out for confidence killers.

WHAT ARE CONFIDENCE KILLERS?

Confidence killers come in many forms, and they often strike when you least expect them to.

- You're rocking it at work, and you get a promotion with a fancy new title, one that you never thought you'd have. You have people reporting to you, with new contributions to make to the team. You're not sure how on earth you're going to be able to do this, convinced your bosses made a mistake to put you in such a big position. You feel imposter syndrome creeping in and hope that nobody finds out you're an over-promoted fraud.
- Your kid comes to you with a problem you're not sure how to solve. Maybe they've moved from elementary school to a new middle school, and they're having a hard time making friends. Maybe your kid is older and out of the house, and they're not calling as much as they used to—they seem really distant, and you're not sure why. Are they just really busy—or is it something you did? You hope and pray that the problem just resolves itself, because you're not exactly sure how to

make the situation better. And you *definitely* don't want to make it worse by saying the wrong thing.

- Maybe your family has recently moved, and you're trying out a brand-new church. You *really* want this to work, so you try to plug your family into all kinds of groups: You attend a ladies' Bible study on Tuesdays, help out at youth group on Wednesdays, host a couples' small group at your home on Sunday nights. You even help out in the nursery on Sunday mornings! You're trying so hard to fit in, to be the cool and fun family who can show up for others and be helpful. But after a while, you notice the schedule is kind of running all of you *ragged*. Between work and school and extracurriculars and church services, you're just not sure how you can manage four *more* church things on top of what you already have. You have no idea which ball to drop, because you love each of those groups and you don't want to let anyone down. The church people need you, right? And they need you to be the perfect, shiny person you've shown you can be. You just *know* they won't like you if you can't help out as much.

Do you see what each of these problems has in common? *Change.* You're encountering new situations all the time, ones that are going to demand new problem-solving skills from you.

So many things can take away your confidence—trust me, I've worked through a lot of them! But I've found three things that I seem to struggle with the most, that sap any confidence I have in myself, and I'm going to talk more about them in the next few chapters. I wonder if you can relate to any of these confidence killers too.

1. Fear

I'm just going to be real with you: I'm afraid of a *lot* of things. I don't like spiders. I don't like scary movies. And I *definitely* don't like snakes. But the thing I'm most afraid of is being abandoned and left alone to figure everything out.

With my background, I can see why. I was abandoned a lot as a kid: by my mom, my birth dad, my stepdad, by friends and leaders I've loved. Some of those had nothing to do with me; other relationships, I sort of drove away before I *could* be abandoned. Sometimes it feels like I live with this underlying dread, this pit in my stomach that tells me that if I'm not perfect, I can't be loved. Because if I mess up, someone is going to leave me like they did before. And that pit in my stomach can drive me to do some crazy things: I try way too hard to be good or fun or an easy, breezy human with no problems or needs. And when that happens, I neglect *myself* before someone else can.

Maybe you're afraid of being abandoned too. Or perhaps you're afraid of being unloved or considered not valuable or not special. Whatever your big fear is, I bet it causes the same sort of pit in *your* stomach too.

2. Inaction

As someone who's a survivor of abuse and trauma, I live with PTSD. My personal brand of PTSD was developed over years and years of traumas happening to me, between my mom and stepdad physically and verbally abusing me, emotionally neglecting me, and betraying my trust over and over and over. Because of this, I (and others who live with PTSD) have a tendency to look for saviors—like, relentlessly. Often when I was younger and met

someone who was wise and capable and seemed sure of themselves, I believed they'd be the answer to my prayers, someone who could pull me out of the hole I was in and get me on a path to thriving, who'd be the person who could love me no matter what. So I'd wait around and let them do things for me. Or I'd beg them for advice, listen, and then do something small, before asking for more advice about more things, and on and on it would go. I couldn't—wouldn't—trust myself to know the next step. I depended on others to tell me what to do, all along hoping they'd do it for me. And until they did, I put everything on hold.

There are kind and wonderful people out there who can inspire you and support you. They can teach you things and show you how to care for yourself in ways you were never taught. But no one can do that *for you*. No one can live your life for you. As hard as it can be, you have to take action and do things to take good care of yourself—because, as an adult, that is *your* job.

3. Comparison

Friend, you know what this one is. If you've ever had a mirror or a phone, you know what it means to compare yourself with someone else—and discover you don't quite measure up.

This may be one of the toughest confidence killers to conquer, because it's not like you can shut off your eyeballs on command. We're always comparing things, whether it's which movie looks more fun to watch, which deal seems better at the grocery store, or which influencer can help us become the best version of ourselves. But gosh, when we turn that lens on ourselves and obsess over all the ways we don't measure up, we fail to recognize something important: What *she's* doing isn't your business.

Your business is your business; your calling is yours and yours alone. And when you obsess over someone else's calling, you're ignoring your own. And when you obsess over perfection instead of the progress you've made in your own calling, you've completely given your power to move forward over to someone or something that you can't control.

TAKE TIME TO RECENTER

If these confidence killers hit home for you, if you feel like you've lost your mojo or never found it in the first place, you're absolutely not alone.

And here's the good news: *You can get your confidence back.*

Because when you feel your head hanging low, God can put his hand gently under your chin and tilt your head back up. I've seen it time and again.

But the struggle is real, y'all. I've been there. People in every single century, from Moses to Joan of Arc to Maya Angelou, have been there too. So if you feel discouraged, I want you to hold your head up—because you're not alone. You can find freedom from the confidence killers, and the first step is to recognize the killers when you see them.

A red flag that says, "Hey, you're spiraling thanks to a confidence killer!" is when negative thoughts begin to overwhelm you. Confidence killers make you anxious, so you'll need a quick way to calm down. The best tool I've ever found is learning how to breathe deeply.

You might be rolling your eyes at me right now. *Learn how to breathe? C'mon, Ashley! I've never needed to learn how to do that!*

Okay, fair point. But this is the kind of breathing that's *really*

going to help you, especially when you feel upset and like you're spiraling. Ever feel like that?

So why am I teaching you how to breathe deeply? Because deep breathing . . .

- **Calms your body down.** It's true—science says so! According to the University of Toledo, when you breathe deeply, you send a signal to your brain that tells your anxiety that you're safe. That return to safety helps turn off your body's "fight, flight, or freeze" response to stress.[1]
- **Brings your focus back to the present moment.** I don't know about you, but when I'm spiraling thanks to a confidence killer, my brain goes a thousand miles a minute. Plus, I start time traveling: Either I'm mad about something that happened in the past, or I'm anxious about something that hasn't happened yet. The thing is, you can control only *what you're doing in the present.* That's it. So when you learn to breathe deeply, you're telling your brain, "You're here right now. You can slow down now."
- **Helps you check in with yourself.** When your brain starts to exit panic mode and move a bit slower, you create the brain space to see how you're doing. And that kind of awareness is going to help you make adjustments so that you can get back to a space where you remember, *Oh, I don't have to be perfect here,* or *Wait. Am I comparing myself when I shouldn't?*

Breathing isn't just for survival, y'all. It can help you *thrive.*
So let's try it!

Right now, I want you to take a hand and put it on your belly. Then I want you to close your eyes and feel your hand move outward as your stomach starts to expand. Count to six as you

inhale; then exhale for six counts. Do that three or four more times. I'll wait.

How do you feel now? Better, right?

Once you've recognized the killer and calmed yourself down, then comes the next step: Remember you can control only so much. I know, ironic. Control makes you *feel* more confident sometimes. But honestly, there's a peace that comes with knowing what you can do and letting go of all the rest, because you know God's going to take care of it.

Peace comes with knowing what you can do and letting go of all the rest, because you know God's going to take care of it.

I think about when my son plays baseball. Now, I'm not super into baseball, but since I want to be a good mama, I've tried to learn a bit more about it. There's something a lot of coaches say in sports: "Trust the process, not the outcome." Well, what does that mean? It means that even though you practice swinging a bat a thousand times, you're *still* not guaranteed to get a hit. That's why even professional baseball players strike out sometimes. Just because those players say, "I'd like to hit a home run," that doesn't mean they'll hit a home run. They can't control that! But what they *can* control is how much they practice. And the more they practice, the better their chances are to get a hit. So they have to make peace with—and be proud of—what they can control: They can practice a lot.

The same holds true with confidence.

Knowing what's your job to take care of will bring you peace and joy. God's given you only so many jobs. He doesn't expect you to handle everything life throws at you. Instead, he gives you what you can handle. Everything else is *his* job to take care of.

The good news is, for all these confidence killers, there are things we can do to regain the confidence we've lost. And in the next few chapters, I'm going to show you how.

Building Your Confidence

The Foundation

- Life changes constantly. That means you need to roll with the punches while staying true to your mission. Trusting that God can help you do that is the key to growing and keeping your confidence.
- There are three big confidence killers to watch out for: fear, inaction, and comparison.
- If you've lost your confidence or never found it in the first place, you can absolutely find it.

The Tools

- **Allow "good enough" to take the place of "perfect."** This doesn't mean you lower your standards for your life. Adopting a "good enough" attitude simply allows you to take the pressure off, stop performing, and enjoy your people just as they are (not to mention yourself!).
- **Calm your body and recenter your thoughts with deep breathing.** Just sixty seconds of deep breathing tells your body that you're okay and you're going to figure out the next best step for yourself.

The Build

- How has your life changed in the last five years? Have you noticed your confidence waning during that season? If so, why? If not, what's kept you centered?

- Which confidence killer do you struggle with the most? Why do you think that is?
- Do you find yourself trying to control things that you actually *don't* have control over? How do you think you'd feel if you focused only on what is your job and handed the rest over to God?
- Spend a few minutes in prayer, asking him to help you notice when your thoughts are spiraling thanks to a confidence killer and to help you focus instead on who you *really* are and who he made you to be.

Breaking Free from Fear

> Be strong and courageous. Do not fear or be in dread of them, for it is the LORD your God who goes with you. He will not leave you or forsake you.
>
> DEUTERONOMY 31:6 (ESV)

HAVE YOU EVER ANSWERED ICEBREAKER QUESTIONS WITH A GROUP of people you don't know?

Of course you have—we *all* have.

Confession: Sometimes I kind of like icebreakers. I know, I know—a lot of people don't really like them, and I get it: Most of the time, they seem kind of lame. But you can learn so much about people from questions that seem small and silly on the surface. If you dig a little deeper and somebody has the courage to "go there," you can find out some interesting things.

One of the most common questions in an icebreaker sesh has got to be "What are you afraid of?" And people come up with the usual suspects: Spiders. Snakes. Scary movies. A big roller coaster drop. The things that make you feel all high-pitched screamy inside (or, if you're me, high-pitched screamy on the outside!).

But you know what? The *real* fears, the big ones that stir your soul with dread, don't come up in these icebreaker moments.

Nobody talks about the three-A.M. nights, tossing and turning, wondering if a parenting decision they made was the right one—and if their kid will forgive them if they were wrong.

They don't talk about the fact that they refused to loan money to a family member again, so scared they'd spend it on drugs or booze, and that family member hasn't called them back. And now they wonder if they're safe.

They don't talk about the fights they have with their partner, the ones that start out so innocently but balloon into name-calling and fears that maybe they're not being seen by the person who's supposed to love them no matter what and maybe they never will be seen and loved for who they really are. Maybe their partner will think, *I didn't sign up for this,* and bail when things become too difficult.

I mean, I get it. Who wants to get into these kinds of conversations with a bunch of strangers? Apparently, I do, because these are all real fears that I struggle with sometimes—and I've just admitted them to you. And just like an icebreaker is supposed to do, now you know a whole lot more about me. Because the fear I struggle with most is the fear of rejection, of abandonment, of being left behind because I just wasn't enough.

That's a normal fear among people like me who have survived long-term child abuse.[1] Knowing that my fear is normal doesn't take it away, even though I wish it did. But I guess this fear explains why I have so much anxiety and why I sometimes find it hard to keep relationships going. I'm so afraid that someone is going to reject me, that my heart will once again feel the searing, white-hot pain of not being worthy. So I tend to shut

down relationships before the other person has the opportunity to reject me.

That's what fear does: It whispers in our ears, telling us that we need to be someone else and act a certain way to be worthy of love from other people. We fear that our God-given desire for connection won't be met, because we're not enough just as we are. And that fear can drive us to do things we wouldn't normally do, which forces us off the path that God has carved out for us.

On some level, we all struggle with the fear of disconnection. Your fear may not look just like mine. Your fear may compel you to lash out in anger, because if you strike first, the other person doesn't have a chance to hurt you. Your fear may tell you that sharing your negative thoughts about someone else with your friend makes you look *so* much better by comparison.

No matter what it looks like, fear distorts our perspective. When our actions are rooted in fear instead of growth, we're not living in the openhearted light of God's love (Jeremiah 31:3). And that's not what he wants for us.

When our actions are rooted in fear instead of growth, we're not living in the openhearted light of God's love.

For so long, I struggled with the idea that I had to be perfect to be loved. I thought if I were better, if I were actually *good,* then my mom and stepdad would treat me better. Kayla and Derek would treat me better. My life would be better if *I* were better.

But eventually, I learned I was wrong. My worth and ability to be loved weren't based on how good I was. Because I could screw up in big, big ways and still be loved by Someone else.

COMING HOME

One Sunday, I sat alone in a pew at church. At first, I'd been accepted into the Cabin Swamp community as a stranger who needed help. But now that the other members were getting to know me better, they held me at a safe distance. Because when they learned that Derek wasn't my husband, gossip started to float around.

And on that Sunday, sitting alone in a pew, I'd had it. I just gave myself over to God and started to worship in true surrender. As the closing prayer finished, I was packing up Braiden's toys when I heard an unfamiliar voice.

"Hi, my name is Kathy."

I turned around and recognized this woman from the choir, petite and in her sixties with short strawberry-blond hair. Kathy Hayes possessed what I can describe only as an unshakable peace. She was rooted, solid, full of joy. And boy, did she love the people Jesus placed in front of her. You could just sense it.

"I couldn't help but be drawn to you," Kathy told me. "You're just so free in your praise, the way you raise your hands. You encouraged me to let myself go and worship too!"

At that moment, Braiden began to stir in my arms, reminding us of his presence.

"Oh, look at how precious he is! How old is he?" She looked at him like she'd just found another grandson.

We got to talking, and she asked me more about my life. I'd learned through the years to keep my responses to these ques-

tions short and sweet, careful not to reveal too much. But for some reason, I began to tell Kathy what was really going on.

"I know me and Derek shouldn't be living together," I admitted to her, "but I don't know what else to do."

Kathy wasn't fazed. Instead, she smiled and said, "Well, how about we just start with lunch and then tackle everything else after that?"

When I walked into her home a short time later, a peaceful heaviness came over me, the kind you feel right before you fall asleep. In time I discovered why I felt that way: Because, in Kathy's home, I finally felt safe. Instead of feeling the need to fight or protect myself, I could rest. It was the best feeling.

. . .

AFTER THAT DAY, KATHY REPEATEDLY SHOWED ME NOTHING BUT KIND-ness. One Sunday, she offered to help me find a new place for Braiden and me to live. True to her word, that Tuesday morning Kathy drove me around town. I can't tell you how many apartment complexes we visited that day. But as I talked to apartment manager after apartment manager, Kathy sat beside me, a kind and patient smile on her face, even as I heard no after no.

"I'm afraid you're not qualified for a lease here."

"Oh, I'm sorry, but we're not taking any new tenants right now."

That's how it went for the entire day. All I wanted was a fresh start, and it seemed like I was never going to be good enough to get one.

We pulled back into Kathy's driveway, and I was exhausted. As we walked into the house, the scent of garlic and onions siz-

zling in olive oil was intoxicating—her husband, Glenn, was making dinner. Kathy asked me to have a seat on their brown couch, a well-worn relic from the seventies. Then she called Glenn over, and they sat next to me.

"Ashley . . ." Kathy began. She started tearing up pretty good, and I braced myself for what was coming next.

"Ashley, Glenn and I have been praying and asking God to provide a home for you and Braiden. Today as we went from place to place, the Lord just made it clear that none of those places were where he wanted you. But he did make it clear to me: Ashley, we want you and Braiden to come live with us."

If you could've seen my jaw, you would've seen it on the floor. I was absolutely stunned, and if I'm honest, at first I felt shaky. A deep unrest filled me at the thought of leaving Derek for good. I was scared to leave what I knew for what seemed like an unknown. Yet I felt God's voice whisper to me, quieting the fear that was building up inside me.

It's okay, Ashley. It's okay to rest. You are safe here. Braiden is safe here. You are going to be okay. I will take care of you.

Calm and peace washed over me. As I looked at Kathy, tears sprang to my eyes, and I finally choked out a happy "Yes!"

. . .

THE DAY I MOVED IN WITH KATHY AND GLENN, I WAS ADOPTED INTO A new family. Sure, I had a child of my own, but I still needed parents who loved me and cared for me. At nineteen years old, I'd finally found a home where I was safe and loved. I'd found a family with a mother who cared for me and a father who would protect me.

To my relief, Derek was also on board with the move. He listened when I shared that God was moving in my life. He knew my heart to follow God with everything I had and was fully supportive.

A few months after I moved in, Kathy helped me line up a slew of health appointments. We started with the one that promised to be the most fun: the dentist (yay), who told me I needed to get my wisdom teeth removed immediately. A few days later, I was back in the chair, feeling so scared but comforted as Kathy sat by my side until I drifted off into an anesthetic slumber.

As we drove back home, the anesthesia began to wear off, and my mouth felt like it had been hit by a sledgehammer—and I became an emotional wreck. I was so hungry; I couldn't eat before the surgery, and it hurt too much to eat after. Plus, the pain meds were making me feel *so* weird (if you've ever seen that old viral video "David After Dentist," then you *know* what I'm talking about). And loopy little me thought, after surgery, Kathy and I would run our errands in town like we usually did. We had a ritual where we'd go to Ruby Tuesday and Walmart, just the two of us. "I can do it, I promise!" I said, wanting so badly for everything to be normal—before I promptly fell asleep. I was in and out of sleep for a while, actually. Through it all, Kathy seemed a little short with me, slightly testy. I'm sure I wasn't exactly *fun* to be around at the time, coming down off anesthesia and wanting to do all the same stuff we usually did. And she was having to care for Braiden while I was out of it. At any rate, I think Kathy saw how weird I was feeling and decided to take me home.

When we walked in the door, I lay down on the couch to sleep it all off. And when I finally woke up, the pain was *intense*. What I didn't know at the time was that I was developing three

dry sockets, which hurt *so bad*. And all I could muster was a weak mumble of "Pain meds . . ."

Kathy strongly suggested I eat the soup she'd gotten for me, which makes sense now that I look back at it. I needed some nutrients, and lots of medications require that you take food with them. But at the time, I couldn't imagine eating something with my mouth aching so much and couldn't understand why she wasn't giving me anything for my pain. Once again, I cried out for my meds, and when I did, I wasn't prepared for what I was met with.

All of a sudden, Kathy started screaming at me.

"I. Do. Everything! Why do you act like you do everything for Braiden? Why don't you tell anybody how much I help you?"

I was so taken aback. In pain, confused, and not sure what to say, I simply replied, "What?"

Kathy wasn't done. "Ashley, we do everything for you, and you act so unappreciative!"

Even in my grogginess, the familiar feelings began to wash over me: the white-hot burn of shame and fear. And there was something new mixed into this feelings cocktail: a mama bear ferocity I'd never had.

Still disoriented from the drugs and the pain, I stumbled forward as I tried to pick up Braiden off the floor. Kathy beat me to him and tried to keep me from taking my son. At that moment, I experienced a rage unlike anything I'd ever known. I shoved her out of the way, screaming, "Don't you touch my son!"

Looking back, I know Kathy was trying to protect us as I was still coming out of anesthesia. But in that disorienting moment, she was my enemy. Just another person who had disappointed

me, another person trying to hurt me—and, now that I had a child of my own, someone trying to be my child's mother.

Oh hell, no.

As I staggered through the doorway and into the car, I frantically dialed Derek's number and in pure hysterics told him everything that had happened. He told me to drive to his dad's house two minutes down the road and stay until he was able to come and get me. All the while, I couldn't escape my own feeling that I'd made one of the biggest mistakes of my life. I felt like I'd crossed a point of no return. I felt like I'd lost Kathy's love.

And I walked back into Derek's house.

NOW I'M FOUND

Feeling like you've lost the love of someone you hold dear, whether it's a parent, a partner, a child, or a friend, is one of the most devastating feelings in the whole world. Some of the most bitter crying I can ever remember came from that season, when I felt like I'd done something dumb to lose the love of someone I'd come to consider as a mother. I've felt that sort of despair other times as well. I hope you never have, but I'm sure that you unfortunately know what I'm talking about.

When your fears of disconnection become real right before your very eyes, it's like watching your worst nightmare come true. Because you see that you've made a mistake, that you're not good enough and there's no hope for you. You may even feel like you don't know who you are anymore, and your connection to your confidence severs.

But lucky for us, God is an expert at making hope come alive again. He's really good at redeeming the people and situations we think are lost forever.

In Luke 15:11–32, Jesus tells a story about a son who feels like he's lost his father's love (#relatable). One day, the son tells his father he basically wishes his father were dead so that he could go ahead and collect his inheritance. The father gets the message and, for whatever reason, gives this ungrateful kid the full sum of what's coming to him. The son takes the money and runs away to another country. And there, far from the eyes of anyone who knows who he is, the son spends every penny on what the Bible calls "reckless living" (verse 13, ESV). Yikes.

Eventually, a famine hits the faraway country, leaving the son hungry. He gets the only job he can, as a pig feeder, the lowest possible job to serve the lowest possible animals. His position is so low and he's so hungry, he wants to eat the pods that he feeds the pigs. The son realizes he left his father's home, squandered his inheritance, and fell from being a served son to being a servant of pigs.

The Bible says that one day the son "came to his senses" and thought,

> At home even the hired servants have food enough
> to spare, and here I am dying of hunger! I will go
> home to my father and say, "Father, I have sinned
> against both heaven and you, and I am no longer
> worthy of being called your son. Please take me on
> as a hired servant." (verses 17-19)

The son gets out of the literal pigsty and starts the long walk back home. As he walks, he rehearses how he'll return to his father—not to regain his father's love, not even to regain his lost status, but simply to survive, to be in a safe space.

After what must have been days, maybe even weeks, the son

can see his father's house in the distance. He can make out the outline of the porch, the fence line. He can even see the building where the servants live, and he imagines that this is where he'll spend the rest of his days, warm and well fed. But as he gets closer, he sees something else. It's a figure running toward him as fast as he can. He panics, not knowing who the figure is. He hears the footsteps getting closer and closer and braces himself for whatever's coming.

But to his surprise, he isn't hit with anything. There are no swords. No fists. No yelling or scolding, but only the soft sound of weeping. He opens his eyes and sees a familiar pair of sandals, with a familiar set of feet to match. The son slowly lifts his head and looks into the face of his father.

On the journey back home, he imagined how disappointed and angry his father's face would be when he finally showed back up. But as he looks into his father's face, there is no anger. Instead, tears are streaming down his cheeks, a smile beaming from his lips. The son tries his best to recite his prepared speech, but the father won't let him finish. The father picks up his son, spins him around, embraces him, kisses him, and places a robe on his back and a ring on his finger, saying, "This my son was dead, and is alive again; he was lost, and is found" (verse 24, ESV).

And oh, how they celebrate. The calf, which the father was fattening up and saving for a special occasion, is roasted. He throws what is probably the biggest party that area has seen in a very long time. Can you just imagine how the son feels? In a moment, he went from dead in his poor choices to alive and celebrated. He's come home and found love.

Whenever I read that story, it's impossible for me not to see my own story playing out. I can't count the number of times I've had the same thought as the son: that, because of his mistakes,

he was worthy to be received back only as a servant. After so many mistakes, I, too, have believed it was impossible that I could ever be loved again. Each time I hear his story, I hold my breath, thinking the ending will eventually be different. Yet every time, I'm floored by the faithful love of the father, who won't for a moment entertain his son's attempt to come back as anything less than a son. It must be the same for you. And for me.

GOD'S GOT YOU–ALWAYS

Listen, sis, no matter what you're feeling, no matter how many people have left you, you can trust in this truth: God will never abandon you. Even if you mess up and stray from the path he has for you, he's always there to welcome you back, running to you when you're still so far away so he can hold you in his arms a little bit sooner.

Fear and shame walk hand in hand. And when you feel the sting of shame telling you that you aren't good enough, remember that unconditional love destroys shame, because there is Someone who says, "No matter what you do, no matter who you think you are, I know who you are: You are my beloved daughter." And if God feels that way about you, if he's always there to welcome you into his home like the cherished child you are, then how much confidence does it give you to go out into the world with that title?

When you know that you can mess up and still be loved, that is huge. Because that knowledge can help you shut down any fears you have about being worthy and enough. Because if God says you're enough, then you're enough—*for everyone.*

Sometimes I need to be reminded of this. Remember those WWJD bracelets that were everywhere back in the nineties?

They did a great job of physically reminding people to stop and think about how Jesus might react in any given situation. Maybe we could sort of bring them back in our own way. Maybe you change the lock screen on your phone to a verse that reminds you that you're God's beloved, like 1 John 4:4: "You, dear children, are from God and have overcome them, because the one who is in you is greater than the one who is in the world" (NIV). Maybe you have a totem on your keychain or a charm on a bracelet that reminds you that you belong to God. Maybe you write Scripture on the walls of your home. Maybe you listen to worship music that reminds you of truths like these. Whatever you need to do to remind yourself of your worthiness, do it.

If God says you're enough, then you're enough—for everyone.

So what would you do if you weren't afraid of failing or falling short? What would you do if you were conscious every second that God was on your side and by your side, every step of the way?

- You might ask the nice mom of your daughter's friend to coffee because *you* could use a friend too. She might say no, the coffee date might not make you thick as thieves immediately, but that's okay. You don't have to be best friends with everyone.
- Perhaps it's been a while since your body has felt strong. You miss moving in a way that makes you sweat and tests your

endurance, but you've got so much on your plate. Kids, job, church, house, partner—how are you going to fit one more thing in? Who do you disappoint when you say, "Sorry; I've got to cut my time short here so I can go for a run"? Which ball will you drop? But then you remember: Your body's a temple, and the only person who can care for it is *you*. Everything else will sort itself out.

- You might reach out to a loved one you haven't talked to in a while because the last conversation you had ended badly. You said some awful things you wish you could take back. You've played that moment on a loop in your brain. But you know that connection is powerful. And you know that nothing and no one, even a broken relationship, is beyond redemption. If you reach out and things don't go the way you hoped, God's going to be there to dry your tears and help you heal.

Taking the leap and putting yourself out there, whether it's a small thing like asking someone for coffee or a big thing like trying to restore a broken relationship, is really scary. It's even more scary when you try again after you've failed at something—or failed someone. When you mess up, it might feel easier in those moments to run away and hide so that no one can judge you. As you can see, I've been there.

But, friend, grace was poured into your life a long time ago. It's there, waiting for you to take hold of its healing power, and that grace can wipe away your fear and shame. It's there to remind you that you don't have to run away. Because you are seen and known and loved for who you are, just as you are right now.

Yes, some people might be hurt and take a minute to reconnect with you. Some might never have the desire to reconnect with you at all. But the healthy people you want in your life?

The ones who love you with the unconditional love that God has? They won't leave you when you mess up. And if you have the courage to be vulnerable, you'll be surprised at what God can do with an open heart.

BACK FOR GOOD

Kathy kept calling and calling, but I didn't want to talk. Then one day, while I was back at Derek's apartment, she showed up at my door with food.

"Ashley," she said with tears in her eyes, "we love you. Come home."

Like the father who waited on the porch, scanning the horizon for his lost son, Kathy and Glenn searched for me and brought me back. We talked about what had happened. Kathy even apologized for losing her temper and for letting me leave home that day without coming right after me.

In the world I came from, payback was the basis for most of my relationships. We lived according to the motto "I scratch your back; you scratch mine." Or maybe more accurately, "You hurt me; I'll hurt you so much you'll never want to hurt me again."

I'd been waiting for Kathy and Glenn to lower the boom and shut me out of their lives. There was no way our relationship would ever look anything like it had, right? Yet here we were, sitting in Derek's living room, crying because God had made a way for the prodigal to come home. In Kathy and Glenn, I saw the love of my Father for me: unwavering, unconditional love that tore down the wall of my own self-protection and allowed me to be vulnerable and open enough to accept their love.

Vulnerability is hard. But, it's so, so important, sis. I love how

this reporter summarized Brené Brown's 2010 TEDx talk on the topic: "Vulnerability is not weakness. It's the most accurate measurement of courage. . . . Vulnerability is the courage to show up and be seen when we have no control over the outcome."[2]

I can see what she was talking about. Because even though I went back to Kathy and Glenn, I knew I was making myself vulnerable to more hurt. That's what happens when we stay in relationship with other people: They mess up, and we mess up. Over the next two years, sometimes Kathy, Glenn, and I wouldn't see eye to eye. But every time we fought, they'd welcome me back. And I could rest in the knowledge that I was worthy and wanted. I was enough just as I was.

Sis, life is messy because people are messy. Sometimes it feels safer to keep yourself at a distance, away from the judging eyes of others, so you don't have to wonder what they think of you. But time and again, I've found myself so much happier when I've trusted that God is always with me. With him by my side, I can walk into any room without fear. Yes, I know I might get hurt. But I'm not going to let the fear of getting hurt or rejected, feeling shame, or *whatever* stand in the way of my growth and flourishing.

Is there someone or something new you'd like to invite into your life, but you're scared of exposing your tender self to some potential hurt or failure? Maybe you feel skittish to open your heart and connect with someone else. Maybe you need to have a difficult conversation with a partner, child, or other loved one, but you don't want to risk rocking the boat and hurting your relationship. Each of these situations might result in some stumbling, confusion, or awkwardness. But that doesn't mean you need to run and hide when these things come up. Sometimes life is awkward and confusing. Sometimes we mess up. But through

it all, we can have flourishing relationships that strengthen us emotionally and spiritually, even if they (and we!) aren't perfect.

So don't let fear hold you back from pursuing the life you want or from walking the path you feel called to be on. Don't let the fear of not achieving perfection hold you back from the good things and good people God has for you. Allowing yourself to stay open, to be vulnerable, even when you might get hurt, builds confidence that you're strong enough to withstand the risk of rejection and, eventually, reap the rewards of connection.

Your life and relationships may not always look the way you imagined. That is completely normal—we all feel that way. But when you're willing to pry open your heart and allow it to get marked a time or two, you might find you can still be imperfectly loved by imperfect people. And amid the heartache, you'll gain infinitely more blessings from staying connected and engaged.

As for me, knowing what I know now, I'd choose connection over fear every single time.

Building Your Confidence

The Foundation

- There is nothing you could ever do to separate yourself from God's love. In his eyes, you're always worthy of his grace.
- God's love is always available to us. You're good enough for him, and he's got your back every time you put yourself out there.
- Fear disconnects us from other people. When we make ourselves vulnerable by stepping out in courage, we allow others to see us and love us. That's the kind of connection God wants for us, because it helps us flourish.

The Tools

- **Trust that you're enough, just as you are.** In our culture of perfectionism, we're always striving to do and be more. But there's nothing you have to do to earn God's love. He already thinks you're awesome.
- **Be vulnerable enough to keep your heart open to connection.** God gave us one another to help us flourish. So allow yourself to stay open to people and experiences (and even apologies from those who have wronged you) so that you stay connected to others who strengthen you emotionally and spiritually.

The Build

- Have you ever distanced yourself from someone because you made a mistake or you thought you weren't good enough for them? If you have, why do you think you did that?
- What did it feel like to distance yourself from that person?
- Think about the story of the prodigal son. How does it make you feel to know that God loves you with that kind of love? What kind of confidence does that give to you?

Overcoming Inaction and Avoidance

> I know what I'm doing. I have it all planned out–plans to
> take care of you, not abandon you, plans to give you the
> future you hope for.
>
> JEREMIAH 29:11 (MSG)

DO YOU WANT TO KNOW THE MOST UNDERRATED DISNEY MOVIE?

I'll tell you. It's *The Emperor's New Groove.*

If you are a millennial of a certain age, I bet you watched this and secretly wondered how this unhinged Disney movie about an Incan-emperor-turned-llama-turned-emperor-again got made. It doesn't follow the formula of so many Disney movies. The main character is kind of a jerk. He's not a *princess;* he's a *llama* for most of the movie.

And man, is this movie *funny.*

One of my favorite characters is Kronk, the villain-ish body-guard with a heart of gold and a brain basically made of crayons. You remember Kronk, right? He could talk with woodland creatures and bake spinach puffs and play jump rope with the best of 'em. Not your typical bad guy, that's for sure.

At one point in the movie, Kronk gets into a conversation with himself about whether to save Kuzco, the emperor he's

been charged to, you know, *off*. He's got an angel on one shoulder and a devil on the other, arguing over whether he should let Kuzco, who's tied up in a bag floating down a river, tumble over a waterfall he's heading straight toward. As the angel and devil battle it out, Kronk gets increasingly confused. Should he follow the orders of his evil boss, Yzma, and get rid of Kuzco, or follow his instinct to save a fellow living being? He wants to do the right thing—he's just not sure what it is. And he stays frozen for a second.[1]

I get that. Because that basically happens to me on a day-to-day basis.

Maybe not in the form of an actual little devil and angel on my shoulders, arguing over something so life-and-death, but sometimes it feels like my brain keeps trying to have a conversation with me, telling me what I should be doing. *Ashley, you should have a Reese's Cup Blizzard. Wouldn't that be fabulous right about now? But didn't you decide to cut down on sweets for Lent?* And other times my brain nags me with things like, *I told Braiden he could have a sleepover this weekend, but I've had a long week and am so tired. Ahh, what should I do?*

I mean, those kinds of small thoughts are running through my head every day. And the dialogue can get *loud* (especially when it comes to the whole sugar thing).

But then there are thoughts that are a little bit quieter. They don't come to the surface as easily, maybe because I don't think they're very convenient. *Not right now,* I say to them. Because on a random Tuesday at nine A.M. when you're trying your hardest to kick off another day of work or watching kids and thinking about what to make for dinner and what needs to go on the grocery list and how you're going to break it to your mother-in-law that you're not going to be there for Thanksgiving this year,

who has the time to listen to the voices that say, *I don't think this is the right career for you,* or, *Why are we fighting so often?* or, *This is getting so, so hard. Maybe you should talk to someone?*

So often when you're in the middle of your very full life, rocking the boat can feel like you're opening yourself up to a whole lot of trouble and conflict for no reason. How do you make room for asserting yourself and making a change, whether big or small, when you're trying *so hard* to take care of everyone and everything and barely keeping up as it is?

Gosh, I hear you loud and clear. But, sis, when that still, small voice pipes up, it's time to give it a listen. Because it's going to keep talking, whether you listen or not, and it's probably speaking out for a reason.

WHY YOU MIGHT GET STUCK

Allow me to make some general observations for a sec: When you look around, it seems like men have no problem asserting themselves. They have no problem taking up space or throwing their weight around to make change happen where it suits them, even if it might make someone mad. Women, on the other hand, seem like they'd rather cut off their arm than have someone upset with them. They'd rather suffer in silence than engage in conflict. Why is that?

Researchers have found that women are neurologically wired to be better at empathizing and communicating verbally than men, who tend to have less interest in conversing with others.[2] Along with that neurological wiring, according to psychology professors Saadia Dildar and Naumana Amjad, "women are socialized to abandon personal goals for the benefit of others."[3]

Over generations and generations, women have been taught that their usefulness to those around them is more important than their own thoughts and feelings and aspirations.

Well, geez. No wonder we'd rather cut off our arm than make someone mad at us. For many women, that means avoiding conflict at all costs. But just because we avoid a conflict doesn't mean that it goes away. In fact, "women are more likely to continue to be emotionally taxed when avoiding a conflict [than men]. The emotionality of conflict often does not dissolve when it is avoided and often continues to take its toll."[4]

Wow, did you catch that? Let me say it one more time for the people in the back.

When we try to avoid conflict, we *do not* avoid the feelings of anxiety we're trying to escape from. And when we run from a problem, we're *not* going to feel great about the situation—or ourselves.

That truth explained so much to me. Many times in my life, I've gone with the flow in a situation because I didn't want to make anybody mad. And I wrestled with some awful feelings as a result.

- Once I had a friend who I'll call "Rachel." When I met Rachel, I wasn't in the best place. But over the years, my life started to get a little less confusing and a lot more stable. I found a good husband, my career started to take off, my income situation changed, and I was able to start building a home I was proud of. But the weird thing was, whenever something good would happen in my life, Rachel wasn't happy for me. In fact, she'd be downright dismissive of whatever growth I was experiencing. I'd leave every interaction

with her feeling exhausted, frustrated, and confused. After twelve years of friendship, I heard that voice asking me, *Is this the kind of "friend" who should have open access to your life?*

- I had a work mentor I looked up to so much. They were respected in their field, and I was honored when they took me under their wing; our relationship gave me great contacts and insight. But after a while, I noticed that what this person said in public didn't match how they behaved in private. And watching this mismatch in public and private personas had that voice asking me, *Do you really want to walk under this person's influence?*

- In one of the biggest examples of going along to get along, I even almost married Derek because, at that point, we had two boys together and I thought it was the right thing to do. We sent out invitations; I bought a dress. I wanted a father for my boys, and I thought the best parents were married parents. But that voice inside kept whispering, *Something isn't right here.*

In each of these scenarios, I faced a conundrum: Do I say something to rock the boat and risk wrecking the relationship? Or do I say nothing and force myself to stifle that still, small voice telling me I'm in a situation or relationship that isn't the best for me?

For a while, I went along in these situations and, with one small decision after another, tried to ignore that voice. I abandoned myself, my values, and my goals. I laid my backpack of tools on the ground and refused to take another step on the path God had carved for me. I just wanted to check out for a while.

Listen, I get it. Most of us don't enjoy conflict, and we all need a break from life sometimes. The problem is when we freeze up and never decide to let ourselves "thaw out" and deal

with the situation, because we believe we're safer entombed in our block of ice, where no one can reach us, and we don't trust that we can handle whatever comes our way.

It's kind of silly to think about, entombing ourselves in a block of ice. But honestly, that's what so many of us do. When we face hard moments, our coping strategy is to avoid these problems instead of facing them head-on—and in the process, we freeze our confidence.

Here are just a few ways avoidance and inaction can creep into our lives:

- **Burnout.** You know this feeling, when you live and work on fumes for far too long. We've all experienced some version of this scene: After working like crazy to finish a project under a deadline, you come home to another sink full of dishes, the laundry sitting on the couch, and your youngest screaming for help with their *own* project, which is due the next day (because of course it is). Suddenly the stress of overwhelm engulfs your nerves and causes your body and brain to shut down. It's hard enough for this to happen every so often. But some seasons, we live in a perpetual state of overwhelm like this, even when our bodies and brains weren't designed to stay in that state for long. And digging yourself out of a burnout season is so, so hard. So night after night, the overwhelm takes over, and you shut down. You avoid the work of trying to figure out how to get out of this burnout season and, instead, fall onto the couch to escape into another episode of *The Great British Baking Show.*
- **Decision fatigue.** This is burnout's cousin. Decision fatigue happens because we are, according to some sources, making up to *thirty-five thousand decisions a day!*[5] Uh, no wonder we

can't choose what to have for dinner, let alone what we want to do with our lives.

- **Learned helplessness.** As a child, if you are caught up in moments when what you say or do does nothing to change your circumstances, you can grow into an adult who believes that you have no power or agency to change a situation (this was 100 percent my experience). You may become convinced that nothing you do matters—so you freeze up or refuse to move forward.

- **Fear of cancel culture.** Let's be real: Going against the grain is always hard, but these days, voicing an opinion that goes counter to the majority feels more daunting than ever. Maybe that's because the stakes are higher. More people are listening and can respond if they dissent—with words, threats, or even worse. Saying nothing feels safe, but it also feels like we're trading in our integrity, which might be the most confidence-killing thing we can do. Because who are we if we don't stand up for what we believe in?

- **Anxiety over making the wrong choice.** What if you choose the wrong school for your kid to attend? What if you don't push your parent to go to the doctor when they have a tickle in their throat? What if you go to a church that leads your family in a way that makes you uncomfortable? Weighing choices with big consequences can paralyze us because we don't want to mess up. And sometimes we think, *If I just had a little longer to decide, I'd make the right choice.* But it's never the right time to decide. So we keep putting the decision off.

No matter why you feel stuck, I'm sure it feels safer to stay there than to move forward. You might feel better for a while when you put off a hard conversation. You might feel more

comfortable expressing your displeasure to your partner through passive-aggressive responses instead of saying what's *really* on your mind. You might turn a sticky situation over and over in your head, ruminating on all the ways you could deal with it and tackle anything that might go wrong.

But those ways of coping aren't helping you deal with your source of stress—in fact, according to author and educator Dr. Elizabeth Scott, the practice of avoiding actually *increases* your stress because . . .

- Avoiding problems creates more anxiety.
- People you're in relationship with may find your choice to avoid dealing with a problem frustrating.
- Avoiding problems allows them to fester and grow (because, after all, what you resist *persists*).[6]

Sis, this is when picking up your backpack of tools can come in handy. Because, inside your backpack, God's given you a crowbar of sorts to get yourself out of feeling stuck and a pile of other tools to keep you moving forward. Let's dig in.

TAKE THE FIRST SMALL STEP TOWARD CHANGE

The number-one way to blast through avoidance and inaction is by facing your problem head-on.[7] Wait—don't close this book. I know there's a reason you've been avoiding this problem, so you're probably wanting a clever way around it, right? Sorry, sis. Tough talk here: There is no way around it. The only way out of the problem is to just *go through it*. I know, what a bummer.

When you're stuck, it can feel overwhelming to take steps toward the change you're looking for. But you don't have to

think about *all* the steps you have to take to do the thing you're avoiding. As author and podcaster Emily P. Freeman has said, we just have to do *the next right thing*.[8]

Think about that for a second.

You don't have to decide everything all at once. All you have to do *right now* is to choose what the next right thing is. So how do you figure that out? I like to start by asking myself some questions:

- What is a decision I could make right now that would serve me well?
- How does that decision honor my mission?
- What is the *smallest* step I can take to get started?

When I ask myself these questions, my shoulders drop from around my ears because that kind of permission makes me feel like I have more space to breathe. I don't feel the urgency of having to make thirty-five thousand choices at once; I simply can't do that! But can I make one decision at a time? Yep. I think I can handle that.

How do you put this idea into practice?

Let's say you're acting on a New Year's resolution to be more intentional about caring for your physical and mental health. You make an appointment with your primary care doctor for a physical so you can know what state your body is in and which lifestyle decisions you can make to help yourself flourish.

At your appointment, you tell your doctor that you'd like to work on your mental health and relationships with others; she agrees that's a great goal for you. Before you leave that appointment, she also lets you know that you have high blood pressure and gives you a list of activities as long as your arm to get it under

control: Eat a balanced selection of foods low in salt; keep alcohol to a minimum; enjoy moving your body regularly; manage your stress levels; make sure you're taking medications properly.

Wow, I've got a lot to do, you think. *How on earth am I going to juggle all of this? Where do I even start?*

This is a perfect time to dig up our questions:

- What is a decision I could make right now that would serve me well? *Literally all of them,* you think. *But is there something I could do that fulfills both of my goals? I know Nikki's asked me to go walking with her before. Maybe she wants to walk with me once a week at the park.*
- How does that decision honor my mission? *Well, it does in a few ways. I love to walk, and setting a date every week gets me moving regularly. Walking with Nikki would help us spend time together and strengthen our relationship. Plus, walking and friendship are great for my mental health.*
- What is the *smallest* step I can take to get started? *I could text Nikki and ask if she's free on Tuesday afternoons for a thirty-minute walk.*

After you start walking with Nikki, then you can turn your attention to the next right thing. Maybe you start looking at labels to see how much sodium is in your food or plugging what you eat into a free food-tracking app to measure your sodium intake. Perhaps you download a meditation app or a book on stress management. These are all small steps that can help you accomplish your goal. You just need to give yourself permission to start small.

What's that saying? "The best way to eat an elephant is one bite at a time." Weird metaphor, but it's true.

HOLD SPACE FOR YOURSELF WITH BOUNDARIES

So you've made a decision to do the next right thing for yourself. Yay! Next, you're going to act on that decision, no matter how small the action might be. Before you do, though, there's something you need to know. Sometimes you'll make a choice that upsets someone—and that's okay.

We often choose inaction because we think butting heads with someone is going to jeopardize our relationship. But when we make decisions based on the happiness of someone else instead of our own well-being and mission, that usually means we're about to serve ourselves a heaping dose of resentment.

And the best way to avoid that kind of resentment altogether? Boundaries.

Obviously, I'm not a therapist or mental health expert, but I've been to therapy and am now a *passionate* believer in setting healthy boundaries. But how do you know when to set a boundary? And what is a boundary, anyway?

In her book *Set Boundaries, Find Peace,* licensed therapist Nedra Glover Tawwab said a boundary is "a cue to others about how to treat you."[9] And when you feel discomfort after interacting with someone (for example, anger, burnout, frustration, or resentment), Nedra said that's a sign that you probably need to set a boundary.[10] Or as I like to think of it, you need to draw a line in the sand—like Jesus.

In John 8, a woman stood before a group of men—*holy* men—in her most vulnerable state, having been caught in bed with a man who wasn't her husband. She stood in front of Jesus, under the Pharisees' disapproving gazes, heat rising into her cheeks as they looked at her with scorn. The Pharisees toyed with the idea of stoning her, because that was within their power

at the time, and Jesus silently bent to draw in the sand. We don't know what he drew or wrote. But after he did, Jesus said something that has captured hearts for millennia: "Let any one of you who is without sin be the first to throw a stone at her" (verse 7, NIV). One by one, the Pharisees realized they couldn't cast a single stone at this woman, because they'd have to throw one at themselves too. Then Jesus looked at the woman and said, "Go and sin no more" (verse 11). He handed her a new story where she could see herself not as someone who was condemned but as someone with hope and a future of freedom.

Think about that. The way the Pharisees saw this woman and the way Jesus saw her couldn't have been more opposite. Jesus viewed the woman as the person he created her to be: someone worth standing up for. That is how he sees all of us.

Jesus didn't have to defend this woman, but he did. And he did so with a boldness that didn't require harsh words or a raised voice. Instead, he stooped to the ground, drew some lines in the sand, and laid out how these people needed to treat her. Jesus showed up for this woman by setting a boundary. And through that process, he demonstrated to us two thousand years later what it looks like to show up for ourselves.

You don't have to use a loud voice or big words or gestures. Sometimes it simply takes drawing a line in the sand and saying, "This is what I'm willing to do, and this is when I'll walk away."

As someone who has survived abuse, sometimes I find it really, really hard to speak up and set limits for how people treat me. But I've had to learn how to show up for myself, set boundaries, and maintain those lines in the sand. As Nedra wrote, "We may not feel comfortable having difficult conversations, but we can do it. The short-term discomfort of setting a boundary isn't a reason to continue tolerating the longer-term discomfort of

the issues that inevitably result. Unhealthy relationships are frustrating and damaging to our long-term well-being."[11]

That is some tough love right there but well worth the discomfort. When you stick to your boundaries, when you stand up for yourself, when you choose to act on your own behalf instead of doing nothing, something amazing starts to happen: You believe in yourself. You remember the person Jesus defended over and over, in life and in death. You remember the value of your mission and become a champion of your own well-being. Because you have a clearly defined sense of self, you don't have to melt into someone else.

So when you need a reminder to stand up for yourself against your own Pharisees—maybe against your mom, who questions why you're majoring in fashion even though you love it; maybe against bullies at school or work, who get a rise from tearing you down; or against your passive-aggressive in-laws, who see you as a past version of yourself they can try to control—remember Jesus drawing lines in the sand. Remember that you weren't made to be seen the way the Pharisees saw the adulterous woman: condemned forever. Remember to see yourself the way Jesus sees you: filled with worthiness, a woman with hope and a future. Remember that you can stand up for yourself and your mission in the same way.

When you show up for yourself this way, the bitterness and resentment you feel toward other people begin to dissolve. It becomes a lot easier to love others—even at a distance—when you love yourself. Pretty cool, right?

But how do you know when creating a boundary might be in order? And what does it look like to keep that boundary in place while maintaining a relationship with someone—or to realize that this relationship is unable to go with you into your next chapter?

I'd challenge you to look at how interacting with that person makes you feel. And if there's something about it that makes you feel less than or like you need to change *or* keep yourself from growing in order to stay in relationship with them, then I think it's probably time to take a closer look at adding boundaries there.

Remember my relationship with Rachel from earlier in the chapter?

For a while, I didn't quite see Rachel's dismissive attitude toward my growth as being harmful to me. Throughout our twelve years of friendship, I'd always worked for her approval (which, you'll recall, was very on-brand for me at that point in my life) and even let her stay at my house and drive my car when she needed it. But when my life began to change and hers didn't, it seemed like Rachel needed to find something wrong with my life to feel better about herself. As I began to grow and recognize the kinds of people I wanted around me, I realized that maybe Rachel wasn't someone who needed to have unguarded access to my life anymore.

I began to limit the amount of time I spent with her. I also asked her to keep her harsh comments to herself unless I was asking for her opinion. Unfortunately, that wasn't a boundary that Rachel was willing to respect. She kept criticizing my choices and would even talk about me behind my back. My friendship with Rachel didn't support my growth and who I needed to be, who God was calling me to be, and she wasn't willing to respect my boundary. With a heavy heart, I decided this relationship wasn't a forever friendship; it was meant to be with me only for a season. I pulled away from Rachel for good.

We don't always get boundaries right on the first try; in fact, learning how to stand up for yourself, your health, and your

growth is a lifelong process. Even though I'd had this experience with Rachel, I still struggled to put those boundaries in place.

Sometime after I said goodbye to Rachel, I hired someone to work on a creative project with me. This person started out as a good collaborator, but after a while, we weren't seeing eye to eye and they weren't listening to my suggestions. We'd opened our relationship by laying out some ground rules—as the one bankrolling the project, I'd get final say. But as we continued working, they kept shooting down my ideas, insisting theirs were better. Before long, every time I got an email from them, my stomach lurched. I questioned the worth of my contributions to *my own project*. I wondered, *Should I be feeling this way about someone working on my project?*

I realized this person wasn't willing to respect my boundaries either. So, just like with Rachel, I stood up for myself and reinforced my boundaries in our relationship. I let that person go from the project. I wasn't rude about it; I calmly explained that because they weren't willing to adhere to the working terms we'd agreed to (aka professional boundaries), we needed to part ways. Then I hired someone who *was* willing to honor my boundaries, who *was* willing to listen to me. It was a long and rocky road, and plenty of tears were involved, but I'm so glad I decided to honor my boundaries and what I needed.

Maybe you have a friend like Rachel in your life who keeps trying to step over the line despite your requests not to. Maybe you have in-laws you love but who come over without calling first. Or a boss who thinks you need to be doing work far beyond what you're paid to do. There are so many ways people step over the line.

I know adding boundaries to your relationships and having hard conversations might feel uncomfortable. But, sis, the more

you start setting boundaries, the easier it becomes. You begin to expect the feelings of guilt and discomfort to follow when you say, "This is what works for me. Would you be willing to meet me here?" Over time, you'll find that butting heads with someone else over your decision is less painful than not showing up for yourself. You'll grow in confidence and learn that you don't have to be paralyzed by inaction. You can move forward with the next right step for you and your mission.

Remember: You're worth fighting for here. After all, long before you began to show up for yourself, Christ showed up for you at the cross. He knows your worth, and he's had your back for the longest time!

A PSA ON CANCEL CULTURE

Can you confront someone without canceling them? And what do you do if someone cancels you?

Okay, y'all, buckle up—we're going there.

This is a chapter about moving out of inaction. And I can't think of a force that makes us freeze up with worry that we're going to say or do the wrong thing more than cancel culture.

Right now, we live in a world whose goal is to make everything *easy*. I just ordered some facial cleanser from an online retailer, and it's going to show up on my doorstep tomorrow. I didn't even have to get in my car; I just tapped a few buttons on my phone. It doesn't get much easier than that.

And when we hear an opinion we don't like online, it's never been easier to say something rude, hit a Block button, and kiss that person goodbye. Virtually, of course.

Listen, I get why our culture is beginning to think about how

to hold the wrongdoers accountable. People *should* be held accountable for their actions, especially if they hurt someone else. That's biblical!

And also, we're allowed to disagree with people. Humans have been doing that since the beginning of time because we're made perfectly unique. And that's okay. It's beautiful, even! We just talked in the previous section about how to disagree with someone while maintaining our integrity (that is, how to honor our boundaries).

But what happens when your boundaries bump up against a person—or a culture—that *vehemently* disagrees with you?

Where is the line between canceling someone and just having a conflict with them?

Where is the line between canceling someone and holding them accountable for their actions?

When we cancel someone, are we saying that person is past redemption? That we can't let that person back into society, that we can't recognize their humanity anymore because of something they did?

And when someone cancels *us,* was that person just being hysterical? Or was there some truth to their words? If we realize we've hurt someone else, how do we try to right the wrong we've done?

I don't know if I have any solid answers to those questions, because each situation will require nuance. But here are a few things I do know:

- **No matter what you say, some people just aren't going to like it.** Jesus even told us as much: "Blessed are you when people insult you, persecute you and falsely say all kinds of evil against you because of me. Rejoice and be glad, because

great is your reward in heaven, for in the same way they persecuted the prophets who were before you" (Matthew 5:11–12, NIV).

- **Conflict doesn't always end in resolution.** I wish it did; I wish everyone would see the world the way I do and think that I'm right! But since we aren't in heaven yet (I kid, I kid!), I have to settle for the fact that sometimes I just have to agree to disagree with someone. It's not as comfortable as finding a solution you agree on, but it's possible to move forward in relationship even when you don't agree on everything.

- **We serve a God who loves a redemption story.** Our God loves a good makeover. He can take someone like Paul, who was the number-one persecutor of Christians at the time, and transform him into one of the most profound witnesses the world has ever seen. Did Paul do some awful things before he became a believer? Um, *yeah*. He watched and approved as the members of the Sanhedrin stoned Stephen, a follower of Jesus, to death (Acts 7:58; 8:1). And still, after Paul did those things, God used him to write so much of the New Testament—including verses like "It is God who works in you to will and to act in order to fulfill his good purpose" (Philippians 2:13, NIV) and the ultimate fan-favorite Bible verse: "I can do all this through him who gives me strength" (4:13, NIV).

All of this is true. But it's still super scary when you realize you're in conflict with someone else to the degree that canceling is even being considered. No matter what side you're on, if you're flirting with canceling someone or someone is threatening to cancel *you,* it's easy to crawl back into your ice cube and freeze everyone else out. I can see how it would be tempting to just pretend the problem doesn't exist anymore.

But remember: We're people of action and love. That's how we need to move forward here.

So what do you do if you want to speak out about a person or a message you believe in? What do you do if you see someone getting beaten up online and you're not sure you agree with how they're being treated? What if you want to act in a way that lines up with your mission but doesn't exactly line up with what the crowd is feeling these days?

Here's my advice: Allow yourself to get comfortable with feeling uncomfortable (just like we talked about in the last section). Tough conversations are never easy, and expecting discomfort takes away its power when it shows up. Then follow your conviction, whether that means speaking up in support of or against the topic at hand. People are going to disagree with you, no matter what you do. But as you express your beliefs, remember to treat all the parties involved with as much respect as you can and with the dignity they deserve as beloved children of God, while still holding true to the boundaries surrounding your integrity.

If someone confronts you about something you've done, I'd also challenge you to *stay open*. In these hard moments, you have a responsibility as a believer to keep loving other people (just as Christ loves you *and* loves them too), no matter how they decide to speak to you or about you. When Jesus upset others with his actions, how did he usually respond? He listened to them. He responded calmly and lovingly—but firmly.

Plus, let's be honest: We also need to remember that we're not perfect. We're going to make mistakes. And we need to stay open to the advice and correction of others. We need to keep our hearts open enough to listen to hard words that people have to say to us, weigh them, and see if what they're saying lines up

with God's truths. If they do, we need to take action to correct the wrong we've done and adjust our boundaries accordingly, the way David did when the prophet Nathan corrected him (check out 2 Samuel 12 for the full story). It's a hard thing to do, to keep our hearts open to truth we may not have considered while trying to keep out what isn't helpful or true. But that's our calling as Christians, isn't it?

Speaking truth to power and receiving negative feedback are some of the hardest and most nuanced parts of our journeys. No matter how we come to these situations, God can use them to help us grow, even if that growth comes at a price.

So stay open. Stay truthful. And stay loving.

BREAK AWAY FROM RESISTANCE

So the first step in getting over inaction is to do the next right thing; then we're supposed to enact boundaries that are helpful for us.

But when you encounter a situation where you actually have to *do* something, does your brain ever try to buy time to just sit there? Does it ever say, *Nope, I'm not doing this right now*? Maybe it goes with something a bit less intense like, *I know I'm supposed to think about what the next right thing is and what boundaries might work best for me, but I'll think about that later.* Because figuring it out right now is hard work. But then later comes, and you still don't know how to move forward. So you think about it. And you think about it some more. And more. You think about the problem so much that you end up just sitting there *thinking* without ever *doing* anything. That's called "ruminating."

One thing that happens when we ruminate on a problem— when we turn it over and over again in our minds without a

solution or action—is we develop anxiety. The American Psychological Association says that anxiety is "an emotion characterized by feelings of tension, worried thoughts, and physical changes like increased blood pressure."[12] We all know what this feels like: stomach in knots, shortness of breath, racing thoughts, and sweaty palms. It's intense. So how do you help it?

Do you remember what your eighth-grade science teacher said about Newton's first law of motion? In part, it's the idea that an object "in motion will remain in motion."[13] In the same way, moving your body or activating your mind consistently will keep your body and mind in motion. And moving your body is the number-one recommendation that the Mayo Clinic has for helping you manage anxiety when it creeps into your life.[14]

And, y'all, I can vouch for it! Sometimes, when I'm stuck, I like to move my physical body to get my mind in motion too. If you know me from TikTok, you *know* that a lot of times, for me, that means dancing! For you, that might mean walking outside on the greenway by your house, playing a round of pickleball, taking Pilates, or joining a hot yoga class in the winter.

No matter how you like to move your body, just get moving. It'll make you feel better by getting you out of your head for a bit. And when you revisit whatever conundrum you're trying to work through, you'll find that you're calmer and you have more perspective—or, hey, even a brand-new idea you thought of while you were out! It's ironic, but sometimes a little pause is the best way to move forward.

Now, if you're anything like me, then sometimes getting up and moving isn't the issue. Sometimes sitting down and *actually* doing the work has me stuck. Do you know that feeling? Maybe you have trouble sitting down to write marketing copy for work, you put off tackling a stack of math problems for your statistics

class, or you conveniently look the other way when you walk past the overflowing pile of laundry. Sis, you're battling one of the strongest forces of inaction out there: resistance. And if you let it, resistance will eat away your entire day as you tell yourself, *I don't want to do that,* over and over again.

An easy way to trick your brain out of a resistance mindset is to set your timer for fifteen minutes. Tell yourself that you're going to stay dedicated to the task for fifteen minutes. You're not going to check your phone; you're not going to get a can of lime LaCroix; you're not going to go play with the dog. You're going to start your task. And—here's the magic—at the end of the fifteen minutes, if you want, you can take a break. Though I usually find that I'm so invested in the task by then that I don't really want to stop. Congratulations. You've just beaten resistance and are on your way toward action.

. . .

SIS, IT MAY FEEL SAFER TO STAY IN A PLACE WHERE YOU'RE AVOIDING the big problem in front of you. But as we've seen, staying frozen in avoidance isn't going to get you anywhere. As hard as it is sometimes, pry yourself away from inaction. Discern the next right thing for your life, and take a small step toward that thing. Resolve to stand up for what you believe in and stay true to your mission. Get out of resistance and decision fatigue by moving your body to engage your mind and spirit and move yourself into a new way of thinking. When you do, you'll become confident that you can move toward the life and goals that God has for you. And remember: He's beside you the entire way.

Building Your Confidence

The Foundation

- When we're making a decision, sometimes we find ourselves pulled in several directions. Don't try to make the choice that'll please everyone; make the choice that aligns with your values and your mission.
- Make peace with this idea: You aren't going to make everyone happy with your decisions. And that's okay.
- There are different ways to shift your brain from frozen to active, like moving your body and intentionally pushing through resistance.
- Remember: When someone disagrees with you, stay open and loving through it all.

The Tools

- **Do the next right thing.** Having fewer decisions on your plate gives your brain space to make an unrushed decision—and makes it easier to act on too!
- **Add boundaries to your life.** When we cave in to what people expect of us, that breeds resentment; we get rid of resentment with healthy boundaries. Boundaries say to others, "Here is how much I can give you. And here is where I stop."
- **Get comfortable with feeling uncomfortable.** When you're feeling a little uneasy about something, that doesn't mean you've done something wrong. You may be acting against your people-pleasing impulses—and that's okay!

- **Get your body moving.** Sometimes you need a fresh perspective when it's hard to make a decision. Take a break, and get some exercise. Exercise bathes your brain in neurochemicals that'll help you feel refreshed (plus, you might think of a solution while you're away!).
- **Say goodbye to resistance.** Sometimes we put roadblocks in our own way to protect ourselves from hurt or disappointment. But we can step around those resistance roadblocks by setting a timer and saying, "At the end of fifteen minutes, I can pause this task." Easy, quick, and surprisingly effective.

The Build

- Time to be real: Is there a still, small voice trying to get your attention right now?
- If you answered yes to the question above, think about when that voice pipes up. Are you putting off a decision? If so, why?
- Think about that decision you've been putting off. What's the next right thing for you? How would that next right thing honor your mission and help you on your path?
- Consider the situation you're facing and the next right thing for you. What boundaries do you need to put in place to keep moving in the direction of your mission?

Letting Go of Comparison

> Pay careful attention to your own work, for then you will get the satisfaction of a job well done, and you won't need to compare yourself to anyone else.
>
> GALATIANS 6:4

ONE OF MY FAVORITE PARTS OF MY JOB IS TALKING TO OTHER women. (Remember the bubbly little girl in kindergarten whose mouth ran about a million miles an hour? Some things never change!)

I love connecting with women who have walked where I have and also with those who have taken a different path from me. Whether I'm chatting with other women on TikTok, at virtual events and churches, or one-on-one in my coaching sessions, I love getting to know their hearts: what brings them joy and even what parts of their lives are messy. I feel so much less alone when someone says, "Oh, me too!" I can't get enough of that feeling.

And it doesn't matter where we are—on Zoom, in a DM, or sitting across from each other with coffee in hand—I hear the same struggles tumble from their mouths over and over again:

I should have my life more together.
I should be a mom who likes to play with her kids.
I shouldn't fight with my husband so much.
I should talk to God more.
I should make more money than this.
I should lose twenty pounds so I can fit into those shorts I used to look good in.
I should read my Bible more often.
I should be better than this.

Honestly, I get it. I get why these women feel they need to do more and be more, because so often I feel the same way. But man, it breaks my heart when I hear a woman who can't recognize how wonderful she already is, who can't see the brilliant, resilient, kind, and caring woman God made her to be. She's built a beautiful life for herself, brick by brick. If her life were a house, it's like she's constantly renovating to make it bigger and showier, when it's already a cozy cottage I'd love to spend time in.

. . .

FROM NEARLY THE TIME THEY'RE BORN, KIDS COMPARE THEMSELVES with others. That's one of the first tools they use to figure out the world as they try to sort everything into boxes. And as kids start to categorize things—animals, plants, people—hierarchies emerge: "This is good! I don't like this. I like *this* more." This is especially true when it comes to social hierarchies. Kids are really attuned to when someone they meet is different in some way, and they use social cues they pick up from the world around

them, starting with their parents and other caregivers, to rank these differences: *Pink is the best color for girls,* or, *This brand of shoe is cooler than this other brand.* We start to pick up on these cues when we're running around on the elementary school playground, and they're magnified when we age up into middle school. The kids who have the most cool points are the most popular, of course. Girls value popularity most when they're in sixth and seventh grade, while, for boys, it becomes most important when they're in eighth and ninth grade.[1]

Remember what it was like to be a girl in middle school, getting dressed in a locker room after PE? We compared *everything,* didn't we? Clothes, hair, skin, boobs, who's friends with who, who's dating who, whose parents drive what. And while this habit of comparing ourselves isn't such a big deal in making and keeping friends as it was back then, it doesn't completely go away when we graduate, does it? Nope. It stays with us now more than ever, thanks to social media.

I love social media. It connects me to people I'd never come across otherwise. It's helped me build my business. Social media has even shown me countless videos that have brought a smile to my face on some dark days, led me to resources like recipes and cleaning tips, and given me inspiration when I needed it.

But sometimes it's hard to spend a lot of time online, isn't it? Because content is designed to draw us in. Content usually looks good, but it doesn't always make us feel good.

When all you see is everybody's best stuff and their lives seem to be filled with the most perfect children, homes, vacations, and faith—while you feel like your hair is garbage, you're failing as a parent, your relationship is on the rocks, or your faith is shaky—it doesn't take long to start thinking you could never

measure up. If we let them, our brains will start comparing our lives with the lives we see online. Just like we did when we were little girls.

No wonder I work with so many women who have *should* as such a big part of their vocabularies. When *should* is such a big part of your life, there's usually not a lot of room for your confidence to shine.

Tbh, y'all, we need to shut the *should*s up.

WHEN NEEDING CONTROL *CONTROLS YOU*

I've been a TikTok creator since 2020, when the pandemic hit and there was literally nothing else for me to do. I was stuck in a house with kids, watching videos of other creators who made me laugh and brought me joy. And I thought, *Well, I can do that. God, help me do that.* And he did. I feel so privileged to have a strong (and growing!) community of people who follow me.

On social, I look like I have it all together.

I'm married to a great guy. We have four awesome kids. I have hundreds of thousands of followers on my social accounts. I'm a confidence coach with a pretty website and virtual events where you can learn how to hone your belief in yourself, thanks to the power given to you by a great God.

But, y'all, that's the version of myself that *I let you see.*

What you don't see are the nights I spend typing into my Notes app with tears rolling down my face, trying to analyze how a conversation between me and my husband spiraled into a fight.

You don't see me in bed, rolling onto my side and staring into the dark at three in the morning, when a nightmare about my

abusers has jolted me awake, leaving me gripping the sheets before remembering, after ten harrowing seconds, that I'm thirty-four-year-old Ashley and not thirteen-year-old Ashley.

You don't see me praying to God, pouring my heart out over what messages you all need to hear from me and how I can best share them with you.

You don't see my hands shaking as I'm at my keyboard, trying to figure out how to type this book for you as a woman who's lived with dyslexia her entire life. You don't hear the voices in my head asking, *Why are you writing this book? There are so many women who could share stories better than you.* You don't see my shoulders sag, hear my deep sigh, and watch my confidence deflate as I think about the women who could do this better than me. Not just writing, but all my jobs. And I mean *all* of them: Wife. Mom. Coach. Friend. I see these women when I scroll through my feeds. I see them pop up from my memories, the girls I wished I could be when I was younger.

From the time I was little, I wished I could be somebody else. I remember feeling like I was one step behind, because I was *always* the last person who learned how to do something. I couldn't ride a bike. I couldn't swim. I didn't know how to do my hair. The kids around me were learning these skills from parents and other caregivers who took the time to teach them how to do these things, with so much love and patience. I was lucky if my mom remembered to pick me up from school, instead of a friend's mom feeling sorry for me and taking me home herself.

I longed to have what the other kids did: a family who loved and supported me in tangible ways. And don't forget—when you're a kid, you're hyper aware of what you have and what you lack. And I lacked a lot.

. . .

LET'S FAST-FORWARD TO ADULT ASHLEY, STARTING AROUND 2019.

Adult Ashley is busy, busy, *busy.* She's got kids coming out of her ears, who need meals and rides and homework help and shoes (why do kids need so many *shoes,* and why do they grow out of them so fast?). She's anticipating needs. She's trying to stay fit and look *good* for that man of hers. She's wanting to find ways to contribute to the income and the well-being of her family.

In the meantime, like any good millennial in the late 2010s, she spends the few minutes she has to decompress scrolling through her favorite Instagram feeds. She watches the glossy women in the color-coordinated grids who seem to have it all—and look fabulous while doing it all. *Good for them,* Adult Ashley thinks. *I wish I could be like that too.* But before she can fall into a shame spiral, her attention snaps to her little boy, who's doing somersaults wayyyy too close to the stairs and is just *asking* for a visit to the ER to set a broken arm. She puts down her phone so she can go tend to him.

Adult Ashley has a full life that takes her out of the house and into the world most days, which she's happy about. A normal routine marks her days, even if each day feels like it's bursting at the seams.

That is, until 2020.

The world begins to shut down. The school doors that welcomed her sons for learning—shuttered. The workplace her husband went to every day—not open. Trips to the grocery store—mask up, baby, and speed through the aisles so you don't get this awful virus. Sunday mornings, usually so full of joy—

reduced to a laptop and a lukewarm cup of coffee while singing praise songs that seem weirdly solemn.

There's nowhere to go, 2020 Ashley realizes. *You're doing everything, all at once, inside your living room, which has never felt so small, like the size of a cracker box.*

Meanwhile, her only portal to the outside world is an index-card–sized phone. She spends more time on it than she ever has, mindlessly scrolling for hours and hours, looking for ways to occupy her mind and the seemingly endless days she's going to spend inside her home.

These women look so good *while pandemic-ing,* she thinks. *They are baking bread. They are learning languages. They are somehow renovating their houses and making gift baskets for first responders and staying so centered and filled with faith. How is this even possible?*

She feels so frozen, like there's nothing she can do to change the situation she's in. She feels almost like she's suffocating. She should be one of these women who are inspiring others, but she *can't* be one of those women; she finds it hard to just get out of bed in the morning. How is she going to put together a gift basket for a first responder if she's that deprived of energy?

Over and over again, she looks at what the other women are doing online. Over and over again, she beats herself up for not doing more and being more, just like them.

COMPARISON COMPROMISES

Guys, I've spent a lifetime comparing myself with other women— on the actual playground and the virtual playground. I don't know about you, but I am *tired* of it.

Why am I tired? Because comparison is draining. It's like you walk through your life with a pair of binoculars, straining to see

what someone else has that you don't, when there's so much beauty right where you are. All you have to do is put down the binoculars and take a look.

Look at the relationships you've been blessed with: your family, your friends. Think about your work bestie or your kid's teacher who takes extra time after school to tutor her in math. Remember the sweet cafeteria worker who got you a new chocolate milk when you dropped yours on the way to snack? Or the labor-and-delivery nurse who made sure you had everything you needed during the most vulnerable hours of your life? The greatest blessings are the people God places in our lives.

And look at the physical provisions you have: The food in your fridge, the lights that come on with a flick of a switch. The clothes in your closet, even the pile of shoes you don't wear anymore (thank the Lord for Gen Z, who have embraced cute sneakers). You may not have everything you *want,* but you certainly have everything you *need.*

Look at the life God has given you. Look at the calling he's placed on you and the tools and gifts he's equipped you with to keep you moving on his path for you.

When you spend your days craning your neck to peer over at someone else, studying their path, envying what they have, training yourself to look and talk and be like them—not only are you missing the good stuff you already have; you're also putting *way* too much pressure on yourself to be someone else. You've got too much on your plate already to try to perform a version of someone else's life.

And that's the thing: You're performing what you *think* is a full, highly functioning life. You don't know if that person's life is leaving them with zero capacity to care for themselves. You're

telling yourself a story that's *not true*. Holding yourself to this story, this standard you've built in your head that may or may not be reinforced by society, can easily begin to strangle your capacity to gently care for yourself.

Let's say you're a bright kid who is generally gifted in a few areas—you're great at math, a valued member of the debate team, and a talented French horn player. As you grow older, your band teacher and your parents tell you over and over how masterful you are at French horn; plus, you enjoy it so much that you decide to major in classical performance since you've been dreaming of joining a prestigious symphony orchestra someday. But when you get to college, you start to learn how tough fulfilling your symphony dreams might be, because there just aren't that many spots up for grabs. So you take your practice hours from a modest one or two a day up to six a day, in addition to everything else you have going on—a full class load, a work-study job, volunteering with your sorority. But you feel like you're not doing enough, because you know there are people out there who *aren't* part of a sorority and *don't* have a work-study job and they have even more time to practice than you. And that advantage means they're going to be more talented than you and take those open symphony spots. Meanwhile, you know you're probably going to be stuck being a high school band teacher. Not that there's anything wrong with that—you loved your band teacher!—but your life would be more glamorous and your parents would be prouder and you would be so much happier *if you were so much . . . more.*

More, more, more.

This is what comparison does to your brain: It lies to you. It tells you that everyone's life is awesome but yours and that to be

as awesome as them, you have to be more. Being confident is hard when you refuse to be content with what you already have, when you think you must constantly mold yourself into someone who may not even *exist*.

..

Being confident is hard when you refuse to be content with what you already have.

..

We do this so often. We have this picture in our minds of what someone else has—the beautiful house in the gated neighborhood, the luxury car that signals they've arrived, the job that fills the hole in their life, the perfect partner and children.

Who are we if we never get these things?

Wanting or admiring what someone else has isn't wrong—I mean, there's a reason I have a cabinet full of Stanley cups (#influenced). But when you start obsessing over who and what you're supposed to be and pick yourself apart when your life doesn't measure up, that's a cue that maybe it's time to get your eyes back on your own paper, as my elementary school teachers used to say.

P.S.: Sometimes beautiful houses in gated neighborhoods are built in flood zones. And luxury car repairs are *expensive*. Big new jobs bring big new responsibilities. New hours. New headaches. More time at the keyboard. Less time at your kid's basketball games and laughing with the ladies at book club. Partners have flaws, and kids melt down.

You sure about those fantasies you have of your perfect life?

CUT OFF COMPARISON BEFORE IT STARTS

Comparison is compulsive—it's something you do without really thinking about it. So how do you begin to stop? How do you challenge yourself to stop comparing and start living in the moment, content (and confident!) in who you are?

Let's start with your brain, like so many things do.

Check your thoughts.

The first step in getting rid of comparison is to notice when your thoughts are straying toward putting your whatever—your life, your talents, your possessions—up against someone else's. Notice the way you talk to yourself in these moments.

Are you motivating yourself to try harder, like you're running a race? *C'mon, you've got this. Let's push a little more!*

Or are you tearing yourself apart? *Why aren't you more like her? Why are you failing? Ugh, you're so lazy. You should try harder.*

If your self-talk is more like option B, you may benefit from looking at why you're talking to yourself this way. What does this person have that you want?

Let's use actor Blake Lively as an example.

Say you *really* want to be like Blake. She's married to Ryan Reynolds. (I know, case closed, the end. But wait—there's more!) She's had a lot of success acting on TV and in movies. She's wealthy. She's beautiful. She seems like a well-adjusted (and well-rested!) mother. I mean, she's best friends with *Taylor Swift,* for goodness' sake!

And you are *obsessed* with being more like Blake. You follow every account she follows on Instagram. You buy every product she mentions, including from her own NA beverage line. You've tried every single workout that promises a Blake Lively–type

bod. You pay your stylist way too much money to create her long, layered honey-blond do on you.

Yet . . . you are not Blake Lively. After all this effort, it's *killing you* that you don't have her life, the life you're very sure is very awesome.

Okay, now let's hold a magnifying glass to your thoughts.

- **Am I mistaking an *assumption* for a *fact*?** (Or, put another way, *Is what I'm thinking absolutely true? If so, how do I know?*) For our purposes here, let's ask, *Is Blake Lively's life really that awesome?* If you think it is, how do you *know*? For all you know, she's tired of trying to keep up with Western beauty standards and being flawless every time she leaves her house. She's tired of wondering if people like her for herself or because she's *Blake Lively*. She misses her husband when one of them is gone for weeks at a time for a shoot. She wonders if she's made the right career choices, since she doesn't have the "everything I touch turns to gold" career her husband does. She's terrified of people stalking her children and would give up all the fame in a heartbeat if she could guarantee their safety. Yikes—maybe it's not so fun to be Blake Lively after all.
- **Is this absolutely necessary for me to live a happy, healthy life?** Is it necessary for you to be Blake Lively to be happy? Uh, no. It's not.
- **If I shared these thoughts with a friend, what would they say to me?** She might fangirl with you for a minute, which, fair. But if you shared the extent you've made your life about Blake Lively, maybe she would ask if you were okay.

- **What have I achieved in the past year that I'm proud of?** Ahh, this question is actually all about *you*. How much of that achievement had to do with wanting to be Blake Lively—and how much had to do with being the best version of yourself?

Fictional You's obsession with Blake is, um, a little *extreme,* and I know you may not be as singularly focused on being the exact replica of one person. But you see where I'm going here.

Working hard and achieving things like Blake Lively is okay. Just don't make your whole life about *being* Blake Lively. Unless you *are* Blake Lively reading this. In that case, hi, I love your work and I'm not a creep.

CHALLENGE YOUR TRIGGERS

So much of our lives revolves around us being consumers. And if we're not careful, what we're consuming is going to consume *us.*

There's a reason the social apps on our phones are designed, according to an undergraduate journal of Brown University, to "function like slot machines." We don't know what's waiting for us when we pull the lever of a slot machine, and the feeling of potential reward is addictive. We don't know what'll be in our feed either, and we're excited to see what it might be.[2]

That's why you can't stop looking at your phone every time your show goes to commercial or anytime you're standing in line for your Starbucks order—even though what you're looking at may depress or anger you.

Slowly but surely, you may start to realize how much your phone is controlling you, instead of the other way around. When you recognize the ways your phone can hijack your brain

and the way you think about yourself, then you can put some boundaries in place around the way you use it. You can pull different levers in your life and make space for the people and moments that fill you with a little more joy—and a *lot* more confidence.

Here are a few ways you can make your life a little more comparison-free.

Do a Social Media Audit

Ma'am, you don't have to follow every single person forever. You don't have to like anyone's post or comment, or repost or remix anything that you don't want to. You can opt out of those things at any time.

The next time you tap on your favorite app, I want you to toggle over to the list of people you follow. Think about the kind of content they post: Does it lift you up? Or does it make you feel an emotion you're not looking for when you log in, like anger, envy, or just plain sadness?

Then I want you to unfollow or mute anyone who consistently posts content that makes you feel less than your best. If you find yourself feeling a little ticked off at a friend who posts vacay pics that feel a bit braggy, just mute her for a while. If someone you follow is posting videos that make you think, *My body should look more like that,* or, *If I were a good mom, I'd do a how-to-be-a-person-camp for my kids too,* and you find you're upset, then simply click Unfollow. You don't have to comment with something sassy before you unfollow them. Just take away your presence, and get on with your day.

If you want to fill your feed with stuff that makes you laugh, teaches you how to clean your house or style your look, or

shares inspiring messages, then curate your feed to show you those things! Follow accounts that align with what you're looking for. Make your social media space a place of respite—not a place that triggers your jealousy, anger, or resentment.

Embrace Screen Time Limits

There's a reason we give our kids screen time limits. It's not that screen time is inherently *bad*. It's just easy to spend time on our phones instead of on activities that are *good* for us, like connecting with others and with God and taking care of our hearts, minds, and spirits. That's why we don't let kids have unlimited ice cream either.

Moderation is key, y'all. And we need it too!

Nowadays, there are all kinds of ways to limit the time you spend on your phone or on certain apps. If you have an iPhone, I suggest turning on the Screen Time feature so you can see where you're spending the most time. When I first saw how much time I was spending on my phone in a day—and not just for work stuff—I was legit *shocked*.

But you can easily set time limits on certain apps. On the days I want to be really intentional, I'll set my limits for about thirty minutes. And when I've hit thirty minutes on one of those apps, a message pops up and asks if I'd like to spend a few more minutes on it. Even if I choose to spend a little more time on that app, just having a built-in accountability partner that can help me use my time more intentionally makes a big difference.

Find Something Else to Do on Your Phone

When you've got idle time, I know you don't even *think* about picking up your phone—your hand just moves there, like your

phone has a magnet inside. But if you can't resist picking up your device, you can stop yourself from scrolling by replacing that activity with others on your phone.

Fill your grocery cart for your next delivery so you can get ahead on your chores. Read a book on the Kindle app or about your favorite hobby on Substack. Learn a new language on Duolingo. Play chess, solitaire, or Candy Crush. Heck, you could take your phone on a walk while you play a podcast (psst—mine's pretty good!) and use the PictureThis app to look at all the plants you find.

Your phone is more than just a social media/comparison machine, and you have the power to train yourself out of thinking that way.

Stop Scrolling—and Start Doing

The best thing you can probably do is to just put down your phone altogether and start living your life in the analog world, right alongside the people you love.

Take a cooking class with your friend. Go to the park and swing with your daughter. Volunteer at your local animal shelter on Saturday, and love on the puppies who live there. Bake cookies with your son. And for heaven's sake, go on a real date with your partner where you're not staring at your phones while watching Netflix!

"Tell me, what is it you plan to do with your one wild and precious life?" asked poet Mary Oliver.[3] Nobody wants to answer, "I'm going to spend hours and hours on my phone, pining away for a life I don't have and wishing I were somebody else." So go out there, and *live your one wild and precious life*. (Keyword: *your* life—not somebody else's!)

WATER YOUR GARDEN

When you stop comparing yourself with others, you'll be amazed how much *energy* you have to care for yourself—to water your own garden, so to speak. Here are a few ways to do that:

- **Recognize what you're grateful for about your life today.** Not the way it was or the way it will be. *Today.* Say a prayer of thanks for the dappled sunlight that came through the curtains this morning. For the friend who reached out to see how you're doing. For the genius who discovered iced coffee. What you notice doesn't have to be big; in fact, the smaller, the better. That way you'll be able to spot more things that make you smile!

- **Celebrate the small wins.** Y'all, life is *hard*. That means nothing is too small to celebrate. Did you wash your sheets even though you didn't want to? Success! Did you keep yourself from spending too much at the Sephora sale so you could stick to your Christmas budget? Great job! Did you write that hard-to-send email and get it out of your drafts folder? Be proud of yourself!

- **Treat yourself.** Remember Donna and Tom from *Parks and Rec*? They had a whole day for treating themselves—which they called, rightfully, "The best day of the year!" Donna bought a crystal beetle brooch she didn't need. Tom bought velvet slippers and a cashmere sweater. Nerdy Ben bought a whole Batman costume.[4] While you don't have to go *that* extreme, you can definitely treat yourself to something a little fun, just because! A lip gloss, a spa day using the gift card your

sister gave you. A little self-care and retail therapy don't re-place actual soul care, but it's good to inject some fun into your life now and then.

When you care for yourself, you trust yourself. And when you trust yourself, you're confident you can handle whatever comes your way.

..

When you care for yourself, you trust yourself.

..

RUN YOUR OWN RACE

I'm gonna be real with you: Comparison is something I still struggle with *all. the. time.* And I probably will for a while. Be-cause when you train your brain to look for how you don't mea-sure up, guess what? Your brain is going to go back to that muscle memory over and over again.

But we can retrain our brains to react differently. We can choose to live with confidence. We can choose to be content with the lives we already have, right at this very moment.

We can be filled with goals and dreams, of course. I'm not asking you to put those away, because they can be powerful mo-tivators to keep reaching for something *big,* even if it's not pos-sible today. But when you look at your life and say, "You know what? This is enough for me," that is the gateway to so much peace—and confidence.

These days, I'm making a decision every morning when I wake up to put these kinds of ideas into my head:

- Today I'm going to do my best to act with confidence.
- Today I'm choosing to believe that Jesus is enough for me—and that I'm enough for him.
- Today I recognize that basking in my enoughness means I'm going to look at the girl over there who's killing it and, instead of launching into how I'm supposed to *be* her, I'm going to give her a high five. Because it's *awesome* and *inspiring* to see someone else living out her calling. And then I'm going to bring my eyes back to Jesus and focus on his calling for me.

Remember, sis: Your life is like a big, long race (I know, bleh, but stay with me, all you fellow non-runners). You may not be the fastest runner, and that's okay! Your goal in this race isn't to be the first person to run through the tape at the finish line. That's nice and all, but that's not where your true victory lies. Your *true* victory comes as you try your best to do a hard thing. And if you cross that finish line, you get to celebrate that you participated in the race and gave it your all. Your victory comes as you put one foot in front of the other, when you turn your head and see all the other people running alongside you, trying their best too. It's looking at the crowd and saying a prayer of thanks for the people who showed up to cheer you on.

If we focus on being first, we miss so many small victories along the way. This is the kind of lesson I want to instill in my own daughter. I don't want her to struggle in the same ways I have, especially with comparison. I never want her to feel like she doesn't measure up. Actually, I don't want *any* of my kids to feel this way.

So you know what I do? I try to equip them with positive self-talk. I help them remember that they are the beloved sons and daughter of God, that he's given their lives so much meaning and purpose and made each of them uniquely and wonderfully. I try to teach them to avoid the *should*s by showing them what it looks like to be content—and that means keeping their eyes focused on who Jesus says they are and the blessings they already have, instead of what everyone else has and what they're doing. That way, when the time comes for them to go out into the world, the foundation under their feet feels a bit stronger and more secure. They'll feel like they can walk with confidence, knowing they're made on purpose, for a purpose.

That's my wish for them. For me. And *definitely* for you.

Building Your Confidence

The Foundation

- When you spend less time obsessing over what someone else has, you have more time and space to water your own garden. You can tend to your life and notice your blessings. You make space for joy!

The Tools

- **Check your thoughts.** Not every thought you have is true. Ask yourself if what you're thinking is true and if the standard to which you're holding yourself is fact or fantasy.
- **Challenge your triggers.** Are you set off by people or messages you see on social media or in other areas of your life? If so, try to limit your contact with them, and notice how you feel after a few days.
- **Water your garden.** Take time to cultivate your life as it is today. Invest in your own wellness and self-care with the resources you have. If time is on the short side, try to make margin for these things.
- **Run your own race.** In a race, runners each have their own speed, lung capacity, and more. Don't compare your race with someone else's; stay in your lane, and celebrate your achievements, big and small.

The Build

- Think about the most common *should*s that come up for you. How long have you been struggling with them?
- If you didn't struggle with any of those *should*s, what do you think your life would be like? How much more joy would you walk with?
- Think about the unique gifts that you have right now. How could God use those for good today?

PART III

Healing and Growing Your Confidence

Resilience to Redeem Your Story

> Don't panic. I'm with you.
> There's no need to fear for I'm your God.
> I'll give you strength. I'll help you.
> I'll hold you steady, keep a firm grip on you.
>
> ISAIAH 41:10 (MSG)

I LOVE BEING IN SEASONS WHEN IT FEELS LIKE EVERYTHING IS JUST clicking into place. When the things you dreamed about and prayed for—that job, that partner, that child, that church, that house—seem to be showing up in your life.

I love the days when you're on the right track, when God is blessing you so that you can be a blessing to other people. It feels like you're where you're supposed to be, like the blissful state of your life is an affirmation that you're walking the path God has for you.

Because maybe we still believe that when something's right for you, it's going to be easy.

But what happens when your path is *not* easy?

What if you're living a version of your life that you never ever would've asked for?

What do you do when your life seems to be spiraling away from you, when all you're doing is struggling to keep your head

above water? How can you be confident in yourself and in what God has for you when you're in a season of hardship? What can God do with a story that's filled with pain, when it looks like there's no good ending at all?

That's when he transforms your confidence into a life preserver that looks a bit like resilience.

There are many ways to define *resilience*. Some people call it "mental toughness." That may be accurate, though that makes me think of someone strong and silent, like a cowboy. But I don't think cowboys are the only people who are mentally tough.

I like this definition: *Resilience* is "the process and outcome of successfully adapting to difficult or challenging life experiences, especially through mental, emotional, and behavioral flexibility and adjustment to external and internal demands." That's how the *APA Dictionary of Psychology* describes it.[1]

Sounds a little different from that cowboy, huh?

I like this definition because, to me, it says that resilience isn't something that you *are*. You don't wake up one day and declare, "I am resilient!" Resilience is something you *do*. You flex. You adapt.

This is what we've been talking about together, isn't it? That backpack of tools God has given you? They are the resources you use to adapt to any situation you come across. We've been talking a lot about internal tools that help us build and keep our confidence: cultivating a mission, adding boundaries, watering our garden, getting comfortable with feeling uncomfortable. But we haven't talked much about external resources, the tools outside ourselves that God has given us to help us.

And one of the most helpful resources he's given to us is people.

When we're in a season of struggle, we have a tendency to white-knuckle our faith. I know we've all heard some version of "Just have faith" or "All you need is faith" when we've been in a hard season.

Now, hear me when I say this: Believing that God, the all-powerful Creator of the universe, is on our side is one of the biggest boosts to our confidence. Like we read in Isaiah, he's walking beside us every step of the way: "Fear not, for I am with you; be not dismayed, for I am your God; I will strengthen you, I will help you, I will uphold you with my righteous right hand" (41:10, ESV).

And since he's not here to physically hold us up himself, God sends people who do that for us.

Since he's not here to physically hold us up himself, God sends people who do that for us.

. . .

AT THE DAYTIME EMMYS, AN AWARDS CEREMONY WHERE THEY honor accomplishments in television, usually someone receives a Lifetime Achievement Award. In 1997, that person was Fred Rogers.

By that point, his show *Mister Rogers' Neighborhood* had been on the air for almost thirty years, transforming the emotional lives of children, explaining that feelings don't have to be scary, that we can make friends with them when we invite them in.

He helped children learn how to care for themselves and trust themselves so early. What a saint.

And during the ceremony, when Mr. Rogers began to speak, he of course did what Mr. Rogers always did: Before anything else, he turned to his audience. He didn't talk about himself; he addressed them first.

"So many people have helped me to come to this night. Some of you are here. Some are far away. Some are even in heaven. All of us have special ones who have loved us into being. Would you just take, along with me, ten seconds to think of the people who have helped *you* become who you are? Those who have cared about you and wanted what was best for you in life. Ten seconds of silence. I'll watch the time."

The camera began to show members of the audience. It's interesting to watch the faces of these beautiful, shiny people we see on television quite frequently. Normally, they're so polished. But it didn't take long before their eyes began to shine with tears.[2]

These ten seconds of silence created one of the most powerful moments not only of that evening; it's one of the most powerful moments that's ever been on television.

Because even though they may not be actors on a screen or have names that are known in households across America, our people are so special. No one gets to where they are in life without some help; there's no such thing as a self-made person. We're marked by a thousand kindnesses along the way.

If you were in that Emmys audience, who would you think of? Who's held you up in the moments you were too weak to stand? Who's gripped your hand when you've been scared? Dried your tears when you've been sad? Given you a gentle push when you've needed it? Cheered you on and celebrated with

you when you've accomplished something big? I'll hold some space for you as you think of those people. Go on, now.

stares off into the distance to think about loved ones and starts crying

Have you thought about your people? I have. I'm all snotty and misty-eyed thinking about them, but I'm so grateful for every single one of them.

The people who have held me up have been mentors, like Kathy and Glenn.

They've been therapists and counselors who have listened to me and offered me wisdom.

They've been my children, who have told me I'm the best mom in the world and kept me humble by forgiving me in a heartbeat after I've, um, lost my crap.

They've been my husband and my friends, who have given me shoulders to cry on and reminded me, day in and day out, to keep showing up for myself. They were my resilience aids pretty recently, actually, when I wasn't sure how I was going to show up for my life at all.

WHEN HELP COMES FROM THE UNEXPECTED

A few years ago, our family was in a season of life when everything felt like it was firing on all cylinders. Doug had a ministry job he loved. We had three happy and healthy boys we were in love with. I'd been seeing a counselor and learning more about how to care for myself and love myself through a PTSD diagnosis. I was on the road to healing and growing stronger. Our marriage was going well. And we decided we wanted to add another baby to our family; we were ready if God was willing. Before long, I found out I was pregnant with our fourth baby.

But everything about this pregnancy felt different, right from the get-go.

I'd always *loved* being pregnant. I never got too sick, and I loved feeling the first flutter of my babies, then feeling them press and kick against my belly, saying hi to their mama and reminding me of their sweet presence. I always enjoyed it.

But this pregnancy was, by far, the toughest one I'd ever been through. The nine months I carried this child, I experienced a laundry list of physical issues: restless leg syndrome, back pain, and sciatic nerve pain, to start. Low iron levels led to weakness, vomiting, and bleeding. But after a *freaking hard* nine months, we welcomed Gracelyn Everly, our only daughter, into our family. She came into the world screaming and has never stopped.

· · ·

I LOVE THIS LITTLE GIRL WITH MY WHOLE HEART. I DO TODAY, AND I certainly did when she made her way into the world. But my daughter shook my life in ways I'd never experienced before.

For whatever reason, after I delivered Gracelyn, I couldn't bounce back physically and mentally like I always had after I gave birth. I felt like I couldn't regain a sense of control over *anything*. And I felt like every thought and emotion in my life had been dialed up from 7 to 700, with all of them coming at my brain in a 24/7 flood. It was the most intense experience of my life.

And I had the hardest time getting out of bed in the morning.

When I did get out of bed, I would nurse Gracelyn. And I kept nursing and kept nursing her until she was eighteen months old. That's probably because I was so afraid *all the time* about

what would happen to her if I stopped. I felt like she was two seconds away from danger at all times, and I wanted her with me *always*. I just knew she would be kidnapped. If I watched the news or scrolled on social and saw something devastating happen to another child, I wouldn't be able to get horrific images of what happened to them out of my head for weeks—literal *weeks*—at a time.

I barely ate. I hardly slept. A dark cloud loomed over my thoughts, spilling into my self-talk. This voice, replacing my newly compassionate tone, was low and harsh, telling me that everyone would be better off without me.

During one of Gracelyn's doctor visits, the pediatrician asked me how I was holding up. I confessed that I wasn't doing well at all, that I was struggling with this beautiful, perfect baby and I didn't know why. Today I can see how much compassion he felt for me. He listened and encouraged me to make an appointment with my primary care doctor as soon as I could.

And the next day, as I broke down crying in my doctor's office, I couldn't help but feel like a failure. Like I wasn't being a good mother to my daughter, despite loving her with my whole heart. I was doing something wrong; my body was doing something wrong. She needed and deserved better. And I was sure a better mother would be able to give her what she needed.

As the tears rolled down my cheeks and I heaved with sobs, the heaviness of shame weighed on my shoulders as my doctor gently told me my diagnosis: postpartum depression. And when he prescribed a medication to help me, I went into full-on panic mode, feeling betrayed.

Because, you see, my doctor knew about my family history. He knew that my mother had suffered deeply from addiction. I'd promised myself long ago that I would never *ever* rely on any

sort of drug, prescribed or not. I was certain that I could overcome anything with my faith. I just needed to believe a bit more, a bit harder.

Faith can change a lot of things. But it can't change the chemical imbalance in your brain.

Day after day, I prayed for God to heal me, to help me get out of bed feeling normal for once. But day after day, I woke up, and the heavy blanket of depression felt more suffocating. I was so scared that having a daughter had unearthed something awful inside me that I didn't know was there. And I feared who I'd become if I took the pills that were supposed to help me.

I let the medication sit, untouched, for days on that counter. My sweet friends would come over to check on me, knowing how much I was struggling. After they left, I'd find a Post-it with a note scrawled on it, reminding me that taking medication for depression was exactly like taking Tylenol for a headache and it certainly didn't mean that my faith was weak.

God bless the friends who show up to walk with you in the hard times.

God bless the friends who show up to walk with you in the hard times.

Doug saw these notes, too, and he was so gentle with me through it all. "I love you, Ashley," he'd say. "The choice to take this is entirely up to you and what you think is best for you. I support you either way."

In the haze of that season, I remember asking God for wis-

dom and discernment. I wanted to be a good mother to my children; I wanted to be a good child for him. I felt like I didn't know how to do either of those things. But eventually, I decided to move forward from inaction. I decided to not let the fear of turning into my mother stand in the way of being the mother I wanted to be for my children. So, holding my husband's hand as I swallowed my first antidepressant pill, I chose to believe that while fear may be standing by my side in my hardest moments, so is God. So are my husband, my friends, and everyone else who loves me. With their support and my own determination, I can care for myself in ways that are best for me. And for that moment, what was best for me was trying this medication to see if it would work.

Do you know what else happened to me? I experienced God in a way I never had before. I understood why he'd led me to name my daughter Gracelyn, because, from that day forward, grace became my closest companion, something I'd never truly given myself. I was still striving for worth, still operating with the notion that if I did enough, believed enough, and achieved enough, God would be proud of me and he would make my path straight and easy for me to follow. If I was doing the right thing, it wouldn't be so hard. But it was in my darkest moments that I discovered none of that was true. Because God loved me for simply being me. And he would help me be the best *me* I could be, using the toolbox and quiver of people he'd given to me.

GOD CAN TRANSFORM PAIN

Why does a good God allow us to struggle with hard things? I wish I knew. I really do.

All I know is that what you've gone through, all the pain that

you've experienced, isn't the end of the story. Because if we keep our hands open and outstretched to God, with a posture that says, "Your will be done," he can use the horrible situations we've been through for good. That I can promise you. He can take what the Enemy intended for evil and turn it into healing for you and for the people you meet.

If we let God work through our pain, he can transform it into connection with someone else. There's a reason that soldiers bond so fiercely on the battlefield: They're experiencing so much hardship together, fighting a common enemy. The same holds true with us. Sometimes that enemy might feel like Satan himself—which, yes, I totally get that. But sometimes the enemy might look like addiction. It might look like anger and resentment.

We fight the things that keep us trapped. And what we discover is that sharing our pain gives us the strength to keep fighting, because we've linked arms with someone else. They lend us their strength; we lend them ours. And the result is a bond that's hard to break. That's resilience in action.

In this life, besides a relationship with our Creator, nothing is more valuable or more powerful than human connection. Nothing. And nothing is more common in the human experience than going through a season that you never expected or asked for. So don't be afraid to share your story with someone else. Tell it to a friend. Tell it to a small group. Tell it to a therapist. Tell it to your partner, your pastor. Tell it to kids at a juvenile center who are struggling like you did. Tell it to women seeking shelter from domestic abuse. Tell it to anyone carrying a burden they never thought they'd have to bear. Tell them how you're putting one foot in front of the other.

When you share your story, you'll form bonds that last a life-

time, like soldiers on a battlefield. You'll find camaraderie. You'll connect with someone who understands your struggle, someone who can spot your progress when you can't see it yourself, even when you're not to the other side. Progress is possibility. Progress is hope. And isn't hope why we're all doing this in the first place?

. . .

HAVE YOU EVER BEEN IN A SEASON WHEN YOU FELT SO MUCH UNEXpected darkness but then you witnessed God's unconditional love and grace in a moment that affirmed his goodness even when you doubted it? A moment that revealed hope and beauty in the darkness and brokenness?

I experienced that on a couch with my family as I took medication for my postpartum depression. That dark season, the kind that's often stigmatized and kept hidden, became the breakthrough I needed the most.

It was okay not to be okay. It was okay to give myself grace. It was okay to sit on the couch, eat Ben & Jerry's, and play *Super Mario Odyssey* with my kids. I could be in a season when I didn't have all my stuff together, and my family could take up the slack. Doug could pick up dinner. The older kids could help with loading the dishwasher or taking out the garbage. I didn't have to be afraid that people would bail on me because I wasn't perfect. I could move past feeling frozen, because I had people who would walk with me. I didn't have to compare myself with anybody else; I just had to focus on my own healing.

By simply being present in my reality, caring for myself and allowing myself to be cared for, I connected with my family in a

way that didn't rely on striving for their love, having a perfect appearance, or attending church every Sunday. Even on the days when I couldn't get dressed, I discovered that God's love, shown through the love of my family and friends, was unwavering.

Sis, there are going to be seasons that annoy you and seasons that bring you to your knees. You'll weather some of them better than others. But where your tools are a little lacking, you can reach out and ask someone for help.

- Are you longing for one Sunday morning when you can let go for a little while, but you have three kids under five underfoot?
- Have you been struggling on a cancer journey, and now your doctor has recommended a radically different eating regimen than you're used to? And you have no idea how to make any of the foods she's recommending palatable?
- Did you adopt a sweet pup from the shelter, but you're beginning to regret your decision because your little guy has separation anxiety and won't stop howling and eating your shoes?
- Are you feeling a malaise—or even a darkness—clouding your thoughts, and you're not sure why?
- Did you walk away from a marriage, the one you thought you'd have until your hands and face were crinkled?

Oh, my heart. I know you must be carrying so much. But you don't have to do it alone.

Those burdens you've been carrying for so long, thinking you had to shoulder them alone? You don't have to. Sometimes you can hand over your backpack while you walk so that someone else can carry it for a while. A friend. A Facebook group. A partner. A doctor. A therapist.

It takes a lot of trust—in ourselves, in someone else—to be open and vulnerable, to admit our faults and show our soft undersides.

And vulnerable people? Those are the confident ones. The resilient ones. The ones who know that even if they get hurt while they're being open with someone else, they're going to be okay. They'll know what to do to care for themselves.

It takes strength to stay soft in a world that pushes us to be hard, to be alone. But we're not supposed to do life alone. Resilient people know when they can solve a problem with the tools in their backpack and when it's time to ask to borrow someone else's.

Stay open.

Stay soft.

Allow yourself to cry. To try again.

Believe in love.

Believe in yourself.

Allow yourself to trust in others—and that there will be better tomorrows.

Building Your Confidence

The Foundation

- Life is hard: physically, mentally, spiritually. God knew we'd need help. So along with our toolbox, he gave us one another.
- Confidence looks like sharing our story with others and keeping our hearts open to receive help.
- You're not going to wake up every day feeling 100 percent. And that's okay! Give yourself grace as you heal. Lean on your people and remember: God's love for you is unwavering, even on your worst days.

The Tools

- **Find your people.** Your partner. Your parents. Your friends.
- **Unexpected resources.** Many people are resistant to medication and therapy. I get it. But they've really helped me become more mentally and emotionally healthy.

The Build

- Have you ever gone through a season of struggle? What was it? Did it make you question your confidence—or your faith?
- What was one good thing someone did for you in that season? How did someone show up for you in an unexpected way?

- Have you ever shown up for someone else? How did they react? How did being a support for them make you feel?
- In what ways does God bring good things from hard situations?

Confidence for Your Next Chapter

> If I climb to the sky, you're there!
> If I go underground, you're there! . . .
> I said to myself, "Oh, he even sees me in the dark!
> At night I'm immersed in the light!"
>
> PSALM 139:8, 11 (MSG)

I'VE BEEN AROUND A LOT OF TODDLERS IN MY DAY.

As a mom four times over, sometimes it feels like whole seasons of my life have consisted of watching *Bluey* on repeat, calming temper tantrums, cleaning up Cheerios crushed into the carpet—and that's about it. I love each of my babies, but man, the toddler stage is something I'm *not* going to be sad to kiss goodbye!

Since I'm a toddler expert, I know a thing or two about their favorite words. And if you've had babies of your own or taught the two- and three-year-old class at church, then you *know* which word is most frequently used in *Merriam-Webster's Toddler Dictionary.*

Congratulations on thinking of the correct word: *no.*

No, I don't eat crusts on sandwiches!
No, I don't want to go to bed right now!
No, I don't like CoComelon; *I like* Peppa Pig*!*

When little ones learn the word *no,* it's like they've gained access to a magic wand. Because, in a way, they have. For the first time in their lives, they can verbalize the feelings they've been able to express only through crying, throwing fits, and going limp. When toddlers unlock the word *no,* they learn they have agency over themselves and what happens to them—or at least as much as Mom and Dad will let them have. And boy, do they love to say *no.* A lot. Sometimes too much.

I can do the same thing in my thirties.

Sometimes I catch myself saying no to every person or situation that makes me feel uncomfortable. Which isn't necessarily a bad thing! Like we talked about with boundaries, I think it's a great thing to know yourself and how to care for yourself well. Saying no is a huge part of that. It sets a line around yourself that says, "Inside this line is what I value, and I'm not going to cross this line—or let anything else cross it—because I want to keep these things protected." Fair enough.

But sometimes, if we're not careful, we're not saying no just because we're protecting our values.

Saying no is often an easy choice because it makes us feel safe. Saying no can feel like building a fence around our hearts so nothing harmful can get in. Nothing can hurt us. Nothing can disturb our peace. That sounds nice, doesn't it?

But you know what happens when you build a fence and forget to put in a gate?

You can't let in all the good stuff God has for you. You can't allow yourself to venture out into someplace new. When you don't put a gate in your fence, you shut out the possibility of something new, something greater: a portal to your purpose.

BRAVE ENOUGH TO CLOSE A CHAPTER

It was a beautiful, balmy night in the Outer Banks. I looked across the table at my friend and smiled conspiratorially over our dinner plates as I whispered, "Wanna go walk on the beach?" She nodded, just like I knew she would. We paid the bill and made our way over to the shore, then took our sandals off as we scampered toward the water.

There's something holy about the beach. When I look at the sheet of water stretching to the horizon, I realize how big the world is and how small I am. There's so much I don't know, so much I can't see.

I remember this particular night so well. I was already feeling a little nostalgic; as I breathed in the briny ocean air, it smelled exactly like it did the first time I set foot on the beach at the Outer Banks. It smelled like freedom and possibility. Like hope for a brighter tomorrow.

And that's when I felt something.

Ashley, it's time to leave.

I gasped, looking around to see who I'd heard, if my friend had heard the voice too.

I want you to move your family to Virginia. Tell Doug.

. . .

IN THE PAST, GOD'S PEOPLE ENCOUNTERED HIS PRESENCE IN SO many ways. Today people have a lot of opinions about whether we can still see or feel God. I get it. He's a big God, and we're a lot of people who bring many backgrounds and experiences to our faith; we're going to have some different opinions! But be-

lieve me when I tell you: I *knew* this was God's hand reaching out to me, convicting me. It was time to move our family away from this place that we loved so much and take ourselves to Virginia.

I realize you may have a few questions for me right now, so I'm going to hold a mini press conference to see if I can clear some of this up for you.

So, Ashley, why Virginia?
At the time, I had no idea.
Had you ever been to Virginia before?
Oh yes. Yes, friend, I had. My sister-in-law lived there. I
 visited once. *I did not like it one bit.*

mini press conference over

So. You can imagine my confusion that night on the beach when God told me it was time to pick up the beautiful life I'd built for myself in this special place surrounded by water and love and move it to "why am I supposed to go there?" Virginia.

It had already been quite the season for us Henriotts, especially me. Between giving birth to our daughter in late 2019 and homeschooling through the pandemic lockdown a few months later, all while coping with postpartum depression, anxiety, and PTSD, and trying to be the best wife and mom I could be? I didn't need this new directive. I didn't need one more set of life-altering circumstances to try to figure out. Our family was finding solid ground for the first time in a long while. Why would I want to give that up?

Let me tell you—*I did not want to give that up.*

That night, I told Doug about the message I'd received. It was

a lot for the two of us to digest. And for a while, I told myself that maybe we didn't *have* to leave. Maybe it was just a test. Maybe God was just checking to see if the microphone was on and I was listening. Maybe that was it.

But what's that saying? "If you want to make God laugh, tell him your plans."

Welp. Guess who must've had tears rolling down his cheeks right then? And something inside me could hear him chuckling, because I couldn't shake off this feeling that maybe he was right and we *did* have to leave, even if I didn't know why.

During my quiet time, I would read Scripture and pray about this new, big mission God had for me. I'd pray for discernment on whether we really *should* go, what our lives would look like once we got there, and what it was that God wanted me to do there anyway. I prayed about it for weeks. And I realized over those mornings of prayer and Scripture that saying yes to God sometimes means taking a leap of faith. It sometimes means going to the land he's asked you to go to, even if you don't want to and even if you don't know what you're supposed to do once you get there. It's starting off on the next chapter because you're confident you're equipped with tools for the journey to come.

WEATHERING THE MESSY MIDDLE

As I was reading a devotional one morning, a passage hit my heart like a lightning bolt, and it's stayed with me ever since: *Life is never going to be exempt from things we fear.* In fact, the most successful people in the world are the ones who have *many* insecurities and fears yet decide they're going to move forward anyway.

It's inspiring, isn't it? But now we know we can access that

kind of gumption through the confidence of knowing that we serve a living God who is more powerful than any force in the universe. And he wants to use that power to *help us.*

So, without a fully laid-out plan, Doug and I decided that we were going to move our kids when they finished school at the end of May 2021. Doug had interviewed with an amazing company and gotten a great job in northern Virginia, nestled right in the Shenandoah Valley, with rolling mountains as far as the eye can see.

But opening this new chapter of my mission wasn't exactly problem-free.

When we moved, we found out quickly that we weren't the only ones with the bright idea to move during the pandemic. Housing prices were rising, inventory was falling, and we were getting outbid on house after house. We lived briefly in a home that was up for sale because my brother-in-law knew the landlord. But realtors were frequently showing it to prospective buyers, so for every open house, I'd have to duck out with my nursing baby and figure out where we'd go. I was frustrated. I'd packed up and moved my family, all while juggling a nursing baby and three boys, and now I wondered *when the heck things were going to get a bit clearer.*

"God," I prayed, "I said yes to your big plan. What this big plan is, I don't know. Can you give a sign here? Any idea on what I'm supposed to do next?"

Oof. Have you ever been there, in the messy middle? You've set off on an adventure to do this brand-new thing—you took on a new client, you married your sweetheart, you welcomed a new baby into your life, you moved your family across the country because you felt convicted it was part of your mission—and

then you find yourself in the middle of it all and you have no idea why you did it in the first place. The dreams you had for your life when you took on this new thing hardly resemble the actual day-to-day of it all.

Here you are on the wooded path, and you can hardly see two feet in front of you. *Again.*

Wasn't this all supposed to get easier? Wasn't this supposed to feel fun and exciting, fresh and new?

Many adventures feel that way at first, don't they? But soon those flirty first days in love melt into "Please don't let your cold-as-a-corpse feet touch mine in bed, or I'll smack you upside the head."

The best part of getting older is gaining experience. Writer Oscar Wilde called experience "the name [people] give to their mistakes."[1] After all, I've made my own share of mistakes. The best part is now we get to learn from them. Experience is confidence's best teacher.

So when you find yourself in the messy middle, it's time to reach into your backpack, lay out your tools, and see which ones might help you get where you want to go. I'm all about easy-to-find lists, so below I'm putting the tools we've talked about so far. These tools can help you in all kinds of scenarios where you might find yourself. Don't believe me? Let's walk through a specific situation that you or someone you know may be experiencing and how you could apply these handy tools.

The Tools

Spot the red flags of people-pleasing.	Add boundaries to your life.
Abandon foundational lies.	Get comfortable with feeling uncomfortable.
Speak truth over yourself.	Get your body moving.
Take a step back through self-awareness.	Say goodbye to resistance.
Choose your actions.	Check your thoughts.
Cultivate a mission.	Challenge your triggers.
Learn stories of past heroes.	Water your garden.
Calm your body and recenter your thoughts with deep breathing.	Run your own race.
Trust that you're enough, just as you are.	Find your people.
Be vulnerable enough to keep your heart open to connection.	Make use of unexpected resources.
Do the next right thing.	

Let's say you've recently learned a piece of news about one of your children: Maybe your youngest child is neurodivergent. Since their older siblings are neurotypical, you may not know how to accommodate your child's new-to-you needs. That might bring a little fear and apprehension to your parenting, because just as you feel with all your children, you want to care for their needs; you want to be a good-enough parent for your

kid. I feel you, mama. But the fact that you're concerned about your kid already means you're a good mom. So let's pull out some tools from your backpack and boost your confidence:

- **Find your people.** Sometimes it feels like your family is the only one that's living a certain story, but often that's not true! Ask your child's doctor or school guidance counselor if they know of any groups or resources in town that might offer the help you need for your child. And if you live in a small town with few resources, try online! So many families live in rural areas just like you, and they're having the same experience. Search for podcasts to find general information. Facebook groups and online forums can be great resources to find information, ask for advice, and normalize your experience.

- **Check your thoughts.** Discovering your child has needs that you're not sure how to meet can bring up fear super quickly. You might find your brain going in a spiral, saying things like, *I don't know how to do this. I'm going to mess this up. Our family is never going to look the same. I'm a terrible mother.* Don't berate yourself for these thoughts; try to invite compassion and curiosity into the conversation. Gently ask yourself questions like, *What would you do right now if you weren't afraid?* And, *How do you know that what you're thinking is absolutely true? How could you try to go about this a little more softly?*

- **Speak truth over yourself.** Remember: You have the God of the universe by your side. And he has some truths about who you are and what you're capable of. Think about your favorite scriptures, the ones that empower you the most. I've always loved Philippians 4:13: "I can do everything through

Christ, who gives me strength." Use this verse as a breath prayer to center yourself. While you're breathing in, say to yourself, *I can do everything through Christ.* And while you're breathing out, finish the thought with *who gives me strength.* If you're in a really anxious moment, using breath prayer like this is a great way to breathe deeply (remember that tool?) while also infusing yourself with truth. A double victory, if you ask me.

This example may not directly apply to you, but I bet you can see the benefits of having all kinds of tools that will help you deal with different situations that arise, whether small or large. Maybe you're forced to collaborate with a difficult colleague at work, and you need some ideas on how to move the project forward (without losing your cool). Or perhaps you receive an unexpected bonus check at work—like, a much larger number than you ever have before—but you and your spouse have *vastly* different ideas on how to use that money. Maybe you're having a discussion with your parents about something faith related, and you realize that you think differently from them about the issue. In each of these cases, you can think about the tools you have at your disposal that will help you get through each of these situations with your confidence intact—which we now know means having your own back and standing up for yourself kindly but firmly.

Need a little help knowing which tools to use? Or maybe you're in a season when you find yourself anxious or wrestling with a problem where you can't seem to find a solution? Sis, you may find some answers—or at least some comfort—in talking it out in a journal.

JOURNAL THE TOOLBOX

Y'all, I know it might seem clichéd to say, "Write about it!" But it's been one of the most calming practices I've ever put into my life. When something hard is happening, I write about it. When Doug and I have a fight, I write about it. When I can't see the way forward and I find my thoughts spiraling into an unhealthy place, I say, "Hold on!" and grab a journal. And I don't hold back; I pour out my heart onto the pages. To me, the experience of writing in a journal helps me channel my thoughts. I talk to God in these pages. And even if I haven't found a solution, I feel better. If you're a journaler, too, you know what I mean.

Research backs up the fact that we feel better when we pour out our hearts onto the page. In one 2006 study involving a group of young adults, researchers found that those who journaled for fifteen minutes twice in a week saw a reduction in depression, anxiety, and even hostility. Other studies have found correlations between journaling about difficult experiences and a stronger immune system—writing can *literally* help us be well![2]

While journaling to simply pour out your feelings is cathartic, with a little intention you can also journal to wrestle through a problem. You can dump out your backpack of tools all over your journal page, then pick up a couple of those tools by writing how you think you might use them in your particular situation.

For example, sometimes seasons of work are tough, but it's hard to pinpoint why, let alone what you should do about it. So let's pretend you're having a hard season at work after you said yes to a big promotion you weren't sure you should take. You decide to write about it in your journal. Here's how that might look:

I find myself leaving every day at five, utterly exhausted. My day is jam-packed with meetings, and it seems like my inbox and Slack notifications are never ending. I try to keep up with them, but I can't ever seem to get to inbox zero. I got our third-quarter sales results in, and they're better than I was expecting, especially with how crazy the economy has been lately, but the numbers are still under our projections. The company says they want us to use all our vacation time, but every time I try to request time off, my boss grills me about what it's for and hints that it's probably not a good time for me to leave. And when *she* goes on vacation, she's always emailing me. Is that what I'm supposed to be doing? How in the world am I supposed to keep up with this? I feel bad even going to my doctor's appointments, because I know my inbox is just going to keep filling up and my boss is probably going to say something snarky anyway. I am just so tired.

Whew. You definitely need some journal time. And spa time. And maybe a new workplace? (But that's a convo for another day.)

Now look at your list of tools. Pick them up, one by one, and think about how they might help you:

THE ABILITY TO CHOOSE MY OWN ACTIONS. *You know what? I do have that ability. It doesn't feel like it sometimes when I spend so much time meeting deadlines and answering emails, but I have agency over my own life. I get to decide what works for me and what doesn't. And maybe my job doesn't have to be this way. Maybe my life doesn't have to be this way. Okay, that already makes me feel better.*

BOUNDARIES. *Oh, wow. I can't imagine how I would get away with those. But let's hypothetically say I put in some boundaries. Maybe I could put up an Out of Office message when I'm at a*

doctor's appointment and ask that people hold their questions until I get back. Maybe I could have a ten-minute update meeting instead of asking my team to email; that might shave some messages from my inbox. And if my boss pushes back on my next vacation request, I'll email HR and tell them what's up so they can talk to her about her behavior—because what she's doing is not okay.

GETTING COMFORTABLE WITH FEELING UNCOMFORTABLE. *Ugh. That doesn't sound fun. But what's worse? Coming home every day with a body that's been tensing from anxiety all day and wondering when the next bomb is going to go off in my inbox or with my boss? Or saying, "This is what I'm going to allow myself to do, and this isn't," and sitting in the discomfort of making other people unhappy? This time, I choose me.*

Do you see how journaling your toolbox helps? You go in feeling scattered and upset, and before you know it, when you allow yourself to take a step back and look at the situation (oh, look—another tool!), you allow your mind to connect emotion to action. And you begin to act in ways that support your flourishing. You trust yourself to take care of yourself. Remember: That's what confidence looks like.

THE FINAL BUILD

So how did my own "say yes to the new" situation end up? I wish I'd had my toolbox all shiny and ready to go so I could've used it to help me get through. But I had to discover the tools on my own, as messy as the process was.

A couple of months after our move to Virginia, I was still *fed up*. With life. With myself. With God.

Postpartum depression was raging and ruling my days. I'd gained dozens of pounds since my pregnancy and was feeling so sluggish. I didn't like the way I felt *at all*. And I guess my social algorithms knew, too, because one day I was scrolling through my phone, which was my typical way to disengage from All the Things, and I accidentally clicked on a Live for a health coach. I have no idea why—I just did.

Everything this woman was talking about resonated with me. Get good, quality sleep. Make sure to stay hydrated. Eat in a way that supports your body best. I thought about the message this woman was telling me: *You need to care for yourself so you can care for other people.* It had been a while since I'd put my own self-care and wellness first. Having a baby and moving across the country can easily push self-care to the back burner. But for the first time in a long time, I was inspired to water my own garden (tool alert!). My self-awareness GPS kicked in, and I knew I needed to start caring for and nourishing my body.

I started eating small, healthy meals about six times a day. I started drinking more water (but I didn't give up my Starbucks, and I never will). Did I feel healthy and full of life the next day? No. It was definitely not an overnight thing. But every few days, I noticed little changes. I began to wake up without wanting to turn over and go back to sleep. I had a bit more pep in my step when it was time to get everybody up and wrangled and ready for school or church. I could focus on things. I could work out for a while without getting super tired.

After three months, I was feeling strong and healthy, and I'd lost about thirty pounds. It'd been a *long* time since I'd felt this

good, and I wanted to keep it going. I wanted to help other women feel the way I did.

I started making content about my wellness journey, despite the imposter syndrome I felt. I started coaching clients about nutrition. I enjoyed connecting with them but not, I discovered, as much about the food part. Instead, I loved watching my clients take steps toward their own wellness and wholeness. I loved watching them come into their own, showing up for themselves and claiming lives of wholeness and healing. I loved seeing them walk in confidence.

One day, it hit me: *Maybe I'm not a wellness coach. Maybe I'm a confidence coach.*

Once I realized my mission had shifted a bit, the pieces fell into place. While I'd been showing up for myself, finding community, trusting myself to take care of myself (aka building my confidence), God had been working behind the scenes. Through my vulnerability, he'd built a platform with the videos I'd made during the pandemic, the ones I hoped would bring a smile or two to the people watching. He's helped me run my own race as I try to be the best creator I can be while cheering on other women doing great work in their own circles. So many times, he's helped me feel comfortable with feeling uncomfortable as I've shared hard truths with you. It's not fun to remember certain parts of my story. But if my sharing can help someone else, I'm all for it, and God helps me have the courage to do just that.

But still one of the biggest ways I've seen God show up for me is when he took my yes—my willingness to walk with him to Virginia, timid but confident in his protection of me—and transformed it into something I never would've dreamed of for myself. A way for me to share more and more about what Jesus has done for me. While I'm sharing some hard things I've been

through, I'm also sharing how God helped me get past them. I'm sharing that sometimes life is so, so hard but, with Jesus, we can find a way through it all, and his love for us never changes. I'm sharing that he's the key to my confidence. I know Jesus always has my back, so I don't have to be perfect and all put together. He's got me. And he has you too.

Sis, you don't have to work yourself to death, trying to meet the physical and emotional needs of everyone around you.

You don't have to walk on eggshells to keep others from the discomfort of disagreement.

You don't have to have a five-year plan to feel good about your future.

You don't have to copy other women's lives to be worthy of love and belonging.

Because you are so loved, especially by our God, right now at this very moment, just the way you are. With him, you are enough.

So take that knowledge with you wherever you go. Take it into the boardroom, into the classroom, and down to the DMV. Take it into halls of rejoicing and into quiet pews of mourning. You don't have to pack God's love and your enoughness in a carry-on or in a diaper bag (thank goodness—you have *enough* to remember), because they live inside you always.

No matter where you are, how old you are, what your circumstances are, you have access to the confidence that comes from a strong relationship with Christ. He's with you wherever you go, and he's made you to be a strong, capable woman who can care for herself and flourish both today and in the days to come.

Building Your Confidence

The Foundation

- Say yes to the new—even if you can't see the path that'll take you there.
- You have the tools to get anywhere you want to go. Keep reaching for them.

The Tools

- **Get messy.** When you take on something new—a project, a relationship, parenthood—the middle is bound to be messy. That's okay! Smudge some dirt on your face, pull out your tools, and keep moving.
- **Journal the toolbox.** Try different tools for different situations you're facing to see if any of them can help you out.

The Build

- Think about a time God asked you to do something and your knee-jerk response was "No, thank you." Why do you think you responded that way? What did it feel like to live with that *no* in your heart?
- If you're struggling with whether you should be saying yes to something right now, read this scripture and think about how your life might look different if you decide to let God into this area:

God is a living, personal presence, not a piece of chiseled stone. And when God is personally present, a living Spirit, that old, constricting legislation is recognized as obsolete. We're free of it! All of us! Nothing between us and God, our faces shining with the brightness of his face. And so we are transfigured much like the Messiah, our lives gradually becoming brighter and more beautiful as God enters our lives and we become like him.

2 CORINTHIANS 3:17–18 (MSG)

Confident in Christ

> Remember those early days after you first saw the light?
> Those were the hard times! Kicked around in public, targets
> of every kind of abuse. . . . But we're not quitters who lose
> out. Oh, no! We'll stay with it and survive, trusting all the
> way.
>
> HEBREWS 10:32–33, 39 (MSG)

AS THE CAR SLOWS TO A STOP, YOU OPEN YOUR EYES, PREVIOUSLY closed in a quick prayer, and, from your perch in the back seat, watch a crowd a few feet from the window. You take a deep breath and steady yourself. You feel a little nervous, but you know that you can get through this night and enjoy yourself, even if the nerves are still with you. Then you nod while you gather your dress, and a half second later, the door opens and you step out. Onto yet another red carpet.

The scene is familiar, as is the swell of fans and reporters shouting to grab your attention.

"I love you so much!"

"Turn this way for a photo, please!"

"I stan a queen!"

Your smile grows wide as you laugh. The scene might feel familiar, but will you ever *believe* this crowd is gathered for you, for something you accomplished? Who even knows? No matter

what happens this evening, you're determined to stick to what matters to you: kindness for everyone, but loving God and caring for yourself well above all else.

You know how the red-carpet game goes, so you strike a few poses for photographers, a hand on your hip as you tilt your head this way and that. You're not so bothered thinking about the images they might be capturing, whether or not they're getting the most flattering angle. You want people to like your red-carpet photo on social, because—let's be honest—you're human. But you're not going to let your evening be consumed by making sure the best photo gets seen. Because who you are could never be captured in a single photograph.

You thank the photographers as you answer a few questions from reporters.

"Who would you like to thank for helping you get here tonight?" one journalist asks.

You pause before you answer. You know that you tend to overexplain, especially with this kind of question, because you don't want to hurt anyone's feelings by leaving them out of your answer. But you also know that you can't control the way someone responds to something you do; you can only try your best to be loving and kind. The rest is up to them, and truly, it's none of your business what they think of you. So you simply say, "I have so many people to thank for their kindness and wisdom that got me here. But more than anyone, I have to thank God for blessing my life and bringing me here tonight."

The reporter thanks you for your answer and your time, and as you turn to keep walking, you catch a glimpse of a few friends in the distance. You make your way toward them and give them quick hugs, complimenting one friend's gorgeous scarlet gown, another's purple paisley tux. You love that your friends are such

cool and creative people; you don't think for a second about how you measure up against them.

"Where's your date?" your friend in the gown asks. "Did he stand you up?"

You smile as you think of him. "Nope, he's waiting for me in the lobby. See you guys in there!"

You turn and see your mom fighting the crowd to get to you.

"Oh my gosh, have you seen Blake Lively's dress? It is to *die* for! It's got this cute bustle in the back, like the ones I've been seeing on GownTok. Let's try a bustle out on you—I know you'll look *perfect*!"

You try not to make a face in the midst of her excitement. *Mom, why on earth do you spend time on GownTok?* you think. But you decide not to let that thought escape your lips. Instead, you exclaim, "Wow, Mom, that's so cool! But I just don't think a bustle is for me. Thanks for looking out, though. GownTok sounds amazing—I need to check it out!"

You give her a quick kiss on the cheek and continue to make your way to the lobby to meet your date—when your publicist comes up to you and grabs your arm. "Lady, there's a whole party of execs that you've *got* to meet. It's going to be so great for your career! Come on, let's ditch this thing for a sec so you can go meet them."

You're so thankful to have someone in your career corner who's got your interests in mind. But you promised you'd meet your date promptly at 5:00 P.M. You reach into your bag and pull out your phone, and it reads 4:59. You don't *want* to give your publicist this news—nobody likes confrontation—but you're a woman of your word, and that's what you decide to stick to here. "Oh, that's awesome! Listen, I have to meet my date right

at 5:00, but maybe we can grab a bite with those folks after? I can be all yours then."

The publicist frowns a bit, not looking at all pleased that her suggestion was turned down. You understand, but you're not fazed. You know that everyone has a right to their emotions; you're not responsible for the way someone reacts to you. You give her a quick hug, let her know to text you if the plans firm up, and turn to go meet your date. Normally, your stomach would be in knots after a confrontation, because you didn't make someone happy. But right now, you feel . . . peaceful. Excited. Ready to get your evening underway.

You walk up to the lobby door and grab the ornate brass handle, straight from old Hollywood. You pull it open to find your wonderful date standing there, program in hand. "I've been waiting for you," he says. "Ready to go in?"

"Am I ever," you reply. "Let's go!"

· · ·

LISTEN, I LOVE A RED-CARPET SITUATION. I'VE BEEN HIGH DRAMA SINCE the day I was born, and I just love the pageantry of it all: the gowns, the tuxes, the beautiful people gathering to celebrate some big accomplishment. I've always daydreamed about what it would be like to walk one of these things. And weirdly, the more I've progressed in my confidence journey, the more my daydream has shifted—for the better, I think.

When I was younger, I would've been more obsessed with the way I looked. Now, don't get me wrong. I *love* to get dressed up! I love makeup and hair, and I'm not afraid to say it: I *love* the

way I look with Botox. Whatever makes you happy and doesn't hurt anybody else or Jesus, then by all means, I support you. But I know myself. I would've centered my whole red-carpet evening on looking and being perfect.

But over the years, I've learned that projecting a look of perfection doesn't get you too far. It doesn't even make you *happy*— not really. Because trying to be perfect keeps you on a pedestal, which means you're away from everybody else. You separate yourself so that no one else can reach you. And now we know that's not the key to happiness; connection is.

These days, if I walked a red carpet, while I'd definitely want to look my best, I wouldn't worry too much about it. I'd look in the mirror, smile at myself, and get on with my life. I wouldn't be focused on me—I'd be focused on other people. I'd be curious about who they were and ask questions about them. At the same time, I wouldn't be overly concerned about getting them to like me; that's not the goal of connection. It's to say, "I see you, and I'm glad to see you; there's so much about us that's the same."

I think these red-carpet daydreams I have are a lot like all the situations where we have to put ourselves out there. Are you taking your kid to the playground and looking for another mom to make friends with? Are you walking into a church or a classroom for the first time, wanting to put your best foot forward so that you can fit into a new group? Are you working on a new project that uses your brainpower in ways that stretch you? Are you needing to stand up to someone who's taken advantage of you, and you're ready to put in a boundary that helps you care for yourself?

There are so many ways we put ourselves out there, hoping that other people won't reject us in our most vulnerable state. I

get it—believe me, I do. You know my story, so you can see that progress doesn't always look like a straight line. I've made mistakes on my journey to confidence, and so will you. We'll even get nervous when it's time to be brave. But you know what? *That's totally okay.* We weren't made to be perfect; we were made to trust that God is bigger than any situation and that he will help us pick ourselves up and try again, as hard as it can be.

But now that you've read this book and gone on this journey with me, I hope your path to confidence will be a little bit easier. Because you know that you don't need another person to rescue you. You know how empowering it is to stop comparing yourself with someone else, to take the first brave step away from fear and toward action to create a bright present and future life for yourself. You know that asking for help can be one of the bravest things we ever do, that sometimes bad things happen but we have a great big God who can help us through it all. And when we keep saying yes to him, even when we don't know where that *yes* is going to take us, we can be confident that he'll lead us exactly where we need to go so that we can fulfill a great purpose that he has for us.

Because we are also confident in this truth: "If God is for us, who can be against us?" (Romans 8:31, ESV).

So as you continue to walk this brave path away from fear and toward curiosity about what God has in store for you, remember to be kind to yourself. When you mess up, remember to speak to yourself with the compassion you have for your kid or your best friend. Remember to let God's love for you, along with his plan for your life, fill you with purpose so that no matter what, you can always walk confidently, knowing that he's got your back—and that you have it too.

Acknowledgments

YOU KNOW HOW WHEN THE MOVIE CREDITS ROLL, YOU SEE A BUNCH of people's names at the end—like, *way more* than just the actors' names? That's because it takes a bunch of people to make a movie. And it takes a bunch of people to make a book too. My name may be on the cover, but a whole team of people helped me put this book in your hands. I have a bunch of thank-yous I'd like to hand out.

Thank you to Kristy Cambron, my agent. You took a huge chance on me and have gone to bat for me time and again. I will be grateful to you forever.

Thank you to Kimberly Von Fange, my editor, who spent hours and hours helping me shape these ideas into a full-fledged book. Thank you for every note that asked me to think a little harder and dig a little deeper. It was all so worth it.

Thank you to my amazing publishing team at WaterBrook for

rallying around this book and being the best cheerleaders I could ask for. I am *so* honored to be part of the WaterBrook family!

Thank you to Amy Kerr, who helped me put my words on the page. I hope you know you're stuck with me!

Thank you to Elisa Stanford at Edit Resource. When we met, I was in such a sticky place; I had no idea where to go or even if it was an option, feeling like I'd hit a wall. You spent hours with me on the phone, gently guiding me back to a place of hope when the (ahem) *stuff* hit the fan. And thank you for connecting me with Amy. I appreciate you more than you know!

And my biggest thank-yous go to my family. Braiden, Preston, Rylan, and Gracelyn: Thanks for making me a mama, for making me laugh every single day (and sometimes cry, lol), and for always pushing me to keep going. You are my biggest inspiration and motivation, and I love each of you so, so much. Doug, I could never express just how much you mean to me or how much your love and support have lifted me up over the years. You are the very best—I mean it.

Notes

Chapter 1: WHY DO WE CARE SO MUCH?

1. Mary West, "Maslow's Hierarchy of Needs: Uses and Criticisms," Medical News Today, July 29, 2022, medicalnewstoday.com/articles/maslows -hierarchy-of-needs.

2. Charlotte Hu, "Why Writing by Hand Is Better for Memory and Learning," *Scientific American,* February 21, 2024, scientificamerican.com /article/why-writing-by-hand-is-better-for-memory-and-learning.

Chapter 2: WHAT IS CONFIDENCE?

1. Molly McElroy, "Children's Self-Esteem Already Established by Age 5, New Study Finds," University of Washington, November 2, 2015, washington.edu/news/2015/11/02/childrens-self-esteem-already -established-by-age-5-new-study-finds.

2. Ashley Hamer, "Here's Why Smells Trigger Such Vivid Memories," Discovery, August 1, 2019, discovery.com/science/Why-Smells-Trigger -Such-Vivid-Memories; Anne-Marie Mouly and Regina Sullivan, "Memory and Plasticity in the Olfactory System: From Infancy to Adulthood," in *The Neurobiology of Olfaction,* ed. Anna Menini (Boca Raton, Fla.: CRC, 2010), 368.

3. Sarah Barkley, "Do Positive Affirmations Work?" Psych Central, last modified April 17, 2023, psychcentral.com/health/why-positive -affirmations-dont-work.

Chapter 5: THE LOWDOWN

1. "Deep Breathing and Relaxation," The University of Toledo, utoledo .edu/studentaffairs/counseling/anxietytoolbox/breathingandrelaxation .html.

Chapter 6: BREAKING FREE FROM FEAR

1. "CPTSD (Complex PTSD)," Cleveland Clinic, April 5, 2023, my.clevelandclinic.org/health/diseases/24881-cptsd-complex-ptsd.
2. Brené Brown, quoted in Shelby Skrhak, "'Vulnerability Is Not Weakness' and 4 Other Lessons from Brené Brown," The Upside by Twill, happify .com/hd/vulnerability-is-not-weakness.

Chapter 7: OVERCOMING INACTION AND AVOIDANCE

1. *The Emperor's New Groove,* directed by Mark Dindal (Burbank, Calif.: Walt Disney Pictures, 2000).
2. Rob Pascale and Lou Primavera, "Male and Female Brains: Are They Wired Differently?" *Psychology Today,* April 25, 2019, psychologytoday .com/us/blog/so-happy-together/201904/male-and-female-brains.
3. Saadia Dildar and Naumana Amjad, "Gender Differences in Conflict Resolution Styles (CRS), in Different Roles: A Systematic Review," *Pakistan Journal of Social and Clinical Psychology* 15, no. 2 (2017): 38, www.gcu.edu.pk/pages/gcupress/pjscp/volumes/pjscp20172-6.pdf.
4. Taly Harel-Marian, "To Avoid or Not to Avoid Conflict: Gender Matters," The Morton Deutsch International Center for Cooperation and Conflict Resolution, October 11, 2011, icccr.tc.columbia.edu/to-avoid-or-not-to -avoid-conflict-gender-matters.
5. Eva M. Krockow, "How Many Decisions Do We Make Each Day?" *Psychology Today,* September 27, 2018, psychologytoday.com/us/blog /stretching-theory/201809/how-many-decisions-do-we-make-each-day.
6. Elizabeth Scott, "Avoidance Coping and Why It Creates Additional Stress," Verywell Mind, last modified January 12, 2024, verywellmind .com/avoidance-coping-and-stress-4137836.
7. Scott, "Avoidance Coping."

8. Emily P. Freeman, "Just Do the Next Right Thing," Emilypfreeman
 .com, emilypfreeman.com/do-the-next-right-thing.

9. Nedra Glover Tawwab, *Set Boundaries, Find Peace: A Guide to Reclaiming
 Yourself* (New York: TarcherPerigee, 2021), 9.

10. Tawwab, *Set Boundaries,* 50.

11. Tawwab, *Set Boundaries,* 52.

12. "Anxiety," American Psychological Association, last modified February
 2024, apa.org/topics/anxiety.

13. Jim Lucas, "Inertia & Newton's First Law of Motion," Live Science,
 September 26, 2017, livescience.com/46559-newton-first-law.html.

14. Siri Kabrick, "11 Tips for Coping with an Anxiety Disorder," Mayo
 Clinic Health System, July 20, 2021, mayoclinichealthsystem.org
 /hometown-health/speaking-of-health/11-tips-for-coping-with-an
 -anxiety-disorder.

Chapter 8: LETTING GO OF COMPARISON

1. Michael Thompson, "Episode 80: Help Kids Develop Social Connections
 While Overcoming Anxiety with Dr. Michael Thompson," *Raising Boys
 & Girls,* November 8, 2022, raisingboysandgirls.com/podcast/5-8.

2. "What Makes TikTok So Addictive?: An Analysis of the Mechanisms
 Underlying the World's Latest Social Media Craze," *Brown Undergraduate
 Journal of Public Health,* December 13, 2021, sites.brown.edu/public
 healthjournal/2021/12/13/tiktok.

3. Mary Oliver, "Poem 133: The Summer Day," Library of Congress,
 loc.gov/programs/poetry-and-literature/poet-laureate/poet-laureate
 -projects/poetry-180/all-poems/item/poetry-180-133/the-summer
 -day.

4. *Parks and Recreation,* season 4, episode 4, "Pawnee Rangers," directed by
 Charles McDougall, written by Alan Yang, featuring Amy Poehler,
 Rashida Jones, and Aziz Ansari, aired October 13, 2011, on NBC,
 amazon.com/Parks-and-Recreation-Season-4/dp/B005JR3DA8.

Chapter 9: RESILIENCE TO REDEEM YOUR STORY

1. *APA Dictionary of Psychology,* s.v. "resilience," last modified April 19, 2018,
 dictionary.apa.org/resilience.

2. "Fred Rogers—Lifetime Achievement Award," National Academy of
 Television Arts & Sciences, 1997, watch.theemmys.tv/videos/fred-rogers
 -lifetime-achievement-award.

Chapter 10: CONFIDENCE FOR YOUR NEXT CHAPTER

1. Oscar Wilde, *Vera, or The Nihilists,* 2nd ed. (London: Methuen, 1927), 53.
2. Kira M. Newman, "How Journaling Can Help You in Hard Times," *Greater Good* magazine, August 18, 2020, greatergood.berkeley.edu /article/item/how_journaling_can_help_you_in_hard_times.

About the Author

As a sought-after confidence coach, ASHLEY HENRIOTT is passionate about helping other women weather storms of self-doubt and reminding them they are never too far from God's grace to be redeemed. Whether she's creating captivating content on TikTok, recording an episode of her *Confidence and Coffee* podcast, or guiding clients to set healthy boundaries by saying no and cutting off toxic obligations and relationships, Ashley's practical approach empowers others to reclaim their lives. She lives with her husband and four children in northern Virginia.

TikTok: @ashleyhenriott
Instagram: @ashley.henriott